Complete Color Mixing Guide for Acrylics, Oils, and Watercolors

2,400 Color Combinations for Each

Complete Color Mixing Guide for Acrylics, Oils, and Watercolors

2,400 Color Combinations for Each

JOHN BARBER

STACKPOLE
BOOKS

Guilford, Connecticut
Blue Ridge Summit, Pennsylvania

STACKPOLE BOOKS

An imprint of Globe Pequot, the trade division of
The Rowman & Littlefield Publishing Group, Inc.
4501 Forbes Blvd., Ste. 200
Lanham, MD 20706
www.rowman.com

Distributed by NATIONAL BOOK NETWORK
800-462-6420

First published by Axis Publishing Limited in 2010
Copyright © 2022 Keo Media Limited

Photographs on pp. 1, 2, 3, 24, 27, 80–81, 83, 136–137, 139 © *Winsor & Newton*

Creative Director: Siân Keogh
Editor: Anna Southgate
Art Director: Sean Keogh

British Library Cataloguing in Publication Information available

Library of Congress Cataloging-in-Publication Data

Names: Barber, John, 1932– author.
Title: Complete color mixing guide for acrylics, oils, and watercolors : 2,400 color combinations for each / John Barber.
Other titles: Color mixing manual
Description: First edition. | Guilford, Connecticut : Stackpole Books, 2022. | "First published by Axis Publishing Limited in 2010"—Colophon. | Summary: "With just 25 common paint colors, you can make 2,400 different hues, and they are all illustrated in this comprehensive guide. Better yet, each color mix uses only two paint colors, so matching results are easy to obtain"—Provided by publisher.
Identifiers: LCCN 2021044974 (print) | LCCN 2021044975 (ebook) | ISBN 9780811770279 (paperback) | ISBN 9780811770309 (epub)
Subjects: LCSH: Painting—Technique. | Color guides. | Color in art.
Classification: LCC ND1488 .B37 2022 (print) | LCC ND1488 (ebook) | DDC 750.28—dc23
LC record available at https://lccn.loc.gov/2021044974
LC ebook record available at https://lccn.loc.gov/2021044975

∞™ The paper used in this publication meets the minimum requirements of American National Standard for Information Sciences—Permanence of Paper for Printed Library Materials, ANSI/NISO Z39.48-1992.

First Edition

contents

introduction

Watercolor as a medium developed from topographical drawings worked in monochrome gray or brown ink. Although several artists emerged to produce works in the medium during the 18th century, it was J.M.W. Turner (1775–1851) who developed watercolor into a serious competitor to oil painting through his choice and use of color. Today watercolor is the medium of choice for thousands of painters working in a variety of styles and a broad range of subjects.

Acrylics are readily mixed with water, but once they are dry, they are inert and flexible, and they do not become brittle. They can be applied in any manner from thin liquid washes to solid chunks of paint built up with the palette knife. Acrylics dry within a few hours, a quality that eliminates the problems of dust and cracking encountered with oil paints. Because these polymer resins are inert and, once dry, do not seep, many materials such as sand, metallic dust, or glass can be used to widen the possible range of effects in both craft work and picture making.

Oil paints are made by mixing pigments with drying oils, usually linseed or safflower oil, although artists use many other oils to obtain particular handling qualities. The slow drying qualities of the oil medium enable the paint to be manipulated over long periods, allowing passages of painting to be removed or altered over several days. This does render the handling of freshly painted work difficult and makes the medium unpopular with vacation painters and travelers. For these artists who wish to paint in an opaque manner, acrylics or simply adding white paint (gouache) to watercolors are frequently used alternatives.

ABOUT THIS BOOK

This book on color mixing is intended for both amateur and professional artists, and it should prove invaluable both in the studio and when out painting on location. You can use it to precisely match any shade you want to reproduce in your work. The 25 colors chosen for the color wheels give a comprehensive

range of 2,400 two-color mixes. The selected colors have been chosen as the most useful for a wide range of painting. All the colors can be located in the color charts and matched by mixing only the two colors shown. This innovative method has the great advantage of enabling you to mix the chosen color with the absolute minimum number of colors, thereby obtaining the cleanest and brightest tints possible. The need to add a third or even a fourth color when attempting to match a color is avoided. (Generally, the more colors you mix together, the greater the tendency to produce a dull finished color.)

Each pair of colors is shown in five degrees of a mixture, and on each color wheel percentages are marked as a guide to the proportion of each color that was used to produce the mix. Start with one color at full strength, and then add the second color gradually until the desired color on the wheel is matched. Note that these mixes were made using one manufacturer's paints (Winsor & Newton); colors by other manufacturers will give varying results.

CHOICE OF COLORS

It may seem surprising that several lovely subtle colors are not included. However, by looking at the appropriate color wheels, you will find very close matches to most shades. Experienced painters may find that some of their favorite colors are missing from the charts, but they may be surprised by how many can be replicated extremely closely with other two-color combinations.

MIXING COLOR

When mixing colors, start with the lighter color and gradually add the darker color to it. In this way, you will avoid mixing too much paint. If you start with too much of the darker or stronger color, you will need a great deal of the lighter color to create the tint you are trying to achieve.

how to use this book

Each two-page spread features a named color from the ranges below. In practice, most artists will use far fewer colors than this. Color mixtures are added to each base color in different percentage strengths, which will help you achieve the precise shade you want. The colors are organized into color groups: yellows, reds, purples, blues, greens, and browns, with mix colors chosen as being of most use to artists working in watercolors, acrylics, and oils. The hue variations information at the foot of each two-page spread shows you where to look if your mix is not quite what you want.

WATERCOLOR PALETTE

lemon yellow
cadmium yellow light
cadmium yellow
quinacridone gold
raw sienna
burnt sienna
cadmium red
cadmium red deep
permanent rose
opera rose
perylene violet
permanent mauve
violet
French ultramarine
cobalt blue
cerulean blue
Prussian blue
phthalo turquoise
viridian
permanent sap green
olive green
raw umber
burnt umber
sepia
Payne's gray

ACRYLIC PALETTE

lemon yellow
cadmium yellow medium
azo yellow medium
cadmium orange
cadmium red light
naphthol red light
quinacridone red
permanent rose
permanent alizarin crimson
quinacridone violet
dioxazine purple
ultramarine blue
cobalt blue
phthalo blue green shade
cerulean blue hue
phthalo turquoise
phthalo green blue shade
permanent sap green
olive green
yellow ocher
burnt sienna
red iron oxide
quinacridone burnt orange
raw umber
Payne's gray

OIL PALETTE

lemon yellow
cadmium yellow pale
Naples yellow deep
cadmium yellow deep
orange
cadmium scarlet
cadmium red deep
permanent rose
permanent alizarin crimson
quinacridone magenta
violet (dioxazine)
cobalt blue
cerulean blue (red shade)
French ultramarine
indanthrene blue
manganese blue hue
phthalo turquoise
cobalt turquoise
cadmium green pale
emerald green
viridian
Prussian green
burnt sienna
light red
raw umber

Use the at-a-glance percentage mixes to see what will result from a mix of two colors in a range of five different percentage strengths. The color at the center of the "wheel" is 100 percent of the color named on the spread; the outer ends of the "spokes" are 100 percent strength of the mixer color.

section color: Colors are grouped into primary or secondary colors; related colors appear one after the other.

percentage mix The percentages of each color are indicated, from full-strength main shade at the center to full-strength second color at the edge.

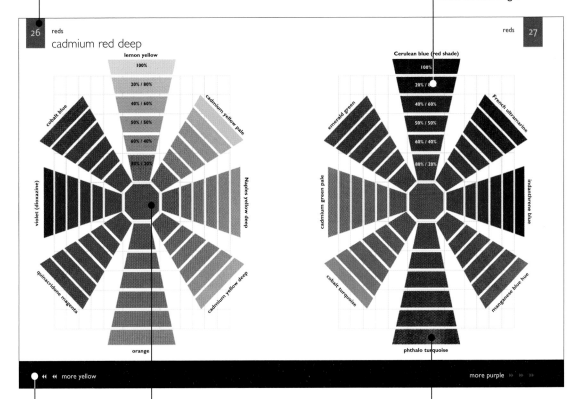

hue variations If your mix is not right, going back in the selector will give mixes containing more of a different color.

base color One of the 25 colors shown opposite appears on every spread, with mixes of percentages of further colors.

mix color Full-strength swatches of the mixer color appear at the ends of the spokes of the color wheel.

understanding color

An understanding of the basics of color theory and the color wheel is very important for every artist. It can help you realize endless creative possibilities for your work. Color, after all, is one of the fundamental tools of painting, and arming yourself with the knowledge of how to use its harmonies, contrasts, and characteristics will help add excitement and dynamism to the paintings you produce.

the color wheel

Successful painting often depends as much on the effects created by your color choice as on composition, which is where an understanding of how color works comes in.

The color wheel is a great reference for artists. The three colors in the center are the primary colors. Primary colors are the ones that cannot be obtained by mixing other colors together. The middle ring shows the colors that are created when you mix two of the primaries. Red and yellow make orange; blue and yellow make green; blue and red make purple. These are called secondary colors and show the colors you can expect to create when you mix primary watercolors in your palette. All colors can, in theory, be created by mixing varying amounts of the primaries. The outer ring breaks down the secondary colors further into 12 shades.

For each picture you paint, you will need a color to represent each of the primary colors so that, by mixing them, you can obtain all the secondary colors. The primary colors you choose should be determined by the scene you wish to paint. For example, if you are painting cool, clear skies and distant hills, choose cobalt blue to represent blue in the color wheel, permanent rose to represent red, and cadmium lemon to represent yellow. All three colors are cool, enabling you to maintain a consistently cool palette—no clashing "hot" colors will appear. Likewise, when painting a warm scene, use warm blue, red, and yellow colors for your primaries. This idea, along with using complementary colors, which appear

opposite each other on the color wheel and produce harmonious contrasts, will help you keep your colors balanced.

A good exercise is to make color wheels for warm and cool colors. Draw several circles 4 inches (10 cm) in diameter and divide each circle into six pie slices. Paint your three primaries in alternate slices and then mix them: red with yellow for orange, blue with yellow for green, and blue with red for purple. Place these secondary colors in between the primaries, and you will see exactly which ones work out well for your picture.

COLOR TERMS

HUE
Hue indicates the strength of a color from full saturation down to white. In practical terms, if you buy any color labeled "hue," it means that the color is less than full strength. This is used as a way of reducing the cost of expensive pigments.

TONE
Tone is the degree of darkness from black to white that creates shade and light. For example, in a black-and-white photograph you can see and understand any object independently of color, solely by its graduation from light to dark. The word "shade" is often used instead of "tone."

COLOR
Color results from the division of light into separate wavelengths, creating the visible spectrum. Our brains interpret each wavelength as a different color. The color wheel is an aid that helps us understand how colors are arranged in relation to each other.

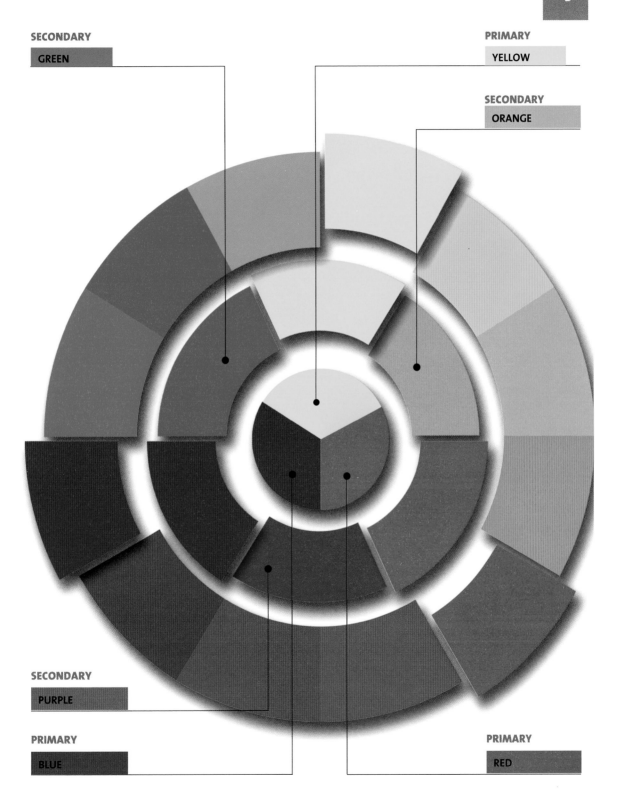

SECONDARY

GREEN

PRIMARY

YELLOW

SECONDARY

ORANGE

SECONDARY

PURPLE

PRIMARY

BLUE

PRIMARY

RED

the color wheel

COMPLEMENTARY COLOR

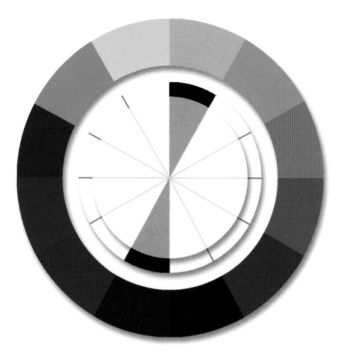

The colors that are opposite each other on the color wheel are called complementary colors. These work together to create a harmonious reaction. Try using them side-by-side in your work—they will each appear to be stronger by contrast, bouncing off of each other.

TRIADIC COLOR

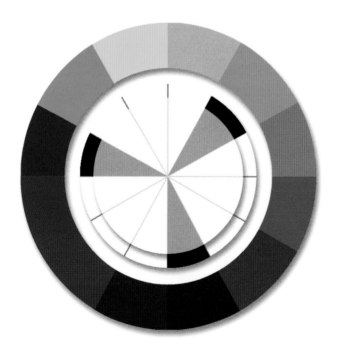

Triadic color occurs when a "chord" of three colors is used in combination. A mixture of any two colors of the triad used next to a third, unmixed color will give many different effects. A triad of colors from any part of the wheel is the basis for a good color composition.

SPLIT COMPLEMENTARY COLOR

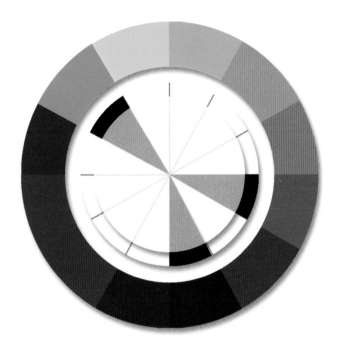

Split complementaries create three colors: the first color, chosen from any point on the wheel, plus the two colors that come on either side of the first color's natural complementary color. These three colors will give plenty of unexpected color schemes.

INDOOR/OUTDOOR TEST

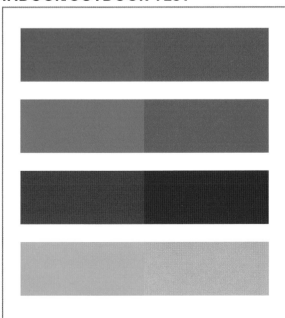

The indoor/outdoor test is designed to show the effect that artificial or subdued lighting has on colors when compared with daylight. If you look at the four strips indoors, you can see hardly any difference between the colors on the right and the ones on the left. Step out into the daylight, and you will be able to see that the right-hand side is noticeably darker. This sort of phenomenon plays an important part in how we perceive color, and all artists have to be aware of it. Although it is never quite as obvious as in the experiment, it does help to explain why art studios are built with high skylights, ideally facing north. For artists whose pictures depend on great color accuracy, good daylight is essential.

watercolor harmonies

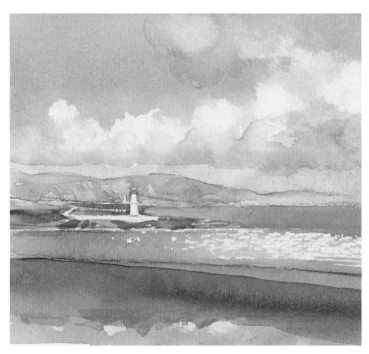

This sketch of the coast of Ireland, with its sparkling waves and fleecy clouds, was painted with a narrow palette of cool blues and grays that suggest pale sunlight and the distance of the coastline. It was created with just three colors—cobalt blue (blue is the coolest color on the color wheel), Payne's gray, and yellow.

This winter scene is created around four colors—cobalt blue, Hooker's green, Payne's gray, and burnt sienna. The most important element is the cool gray background, which establishes that this is a misty day. The dark trees make a series of verticals that create the stillness of the scene. The clever use of burnt sienna makes the other colors look even cooler.

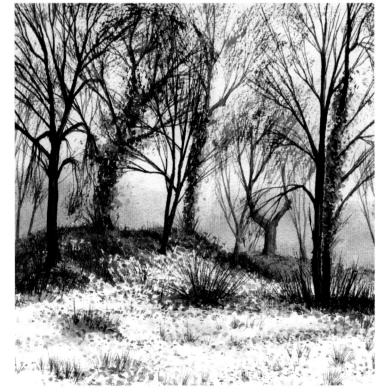

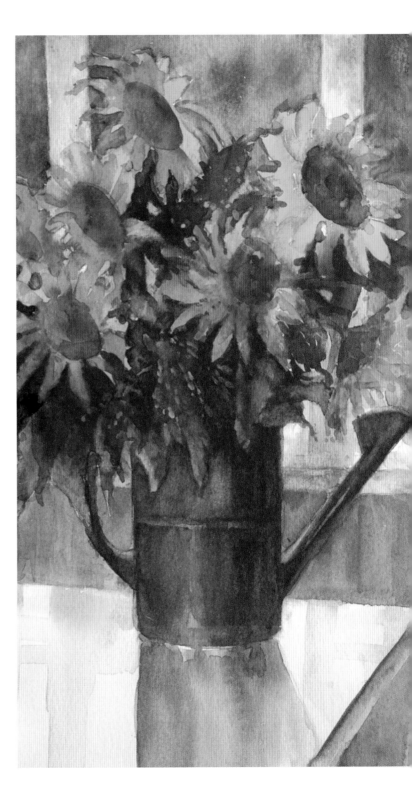

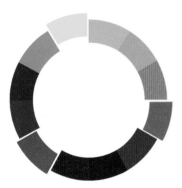

This is a richly painted still life, with warm oranges, reds, and yellows in the flowers, a wide range of greens in the leaves, and a solid rectangle of deep blue in the watering can. The pink wash over the table and far wall brings in purple shades. The blue color of the can is taken up into the background leaves to make a soft, turquoise green. This vibrant still life uses most of the colors of the color wheel to create an overall feeling of warmth.

acrylic harmonies

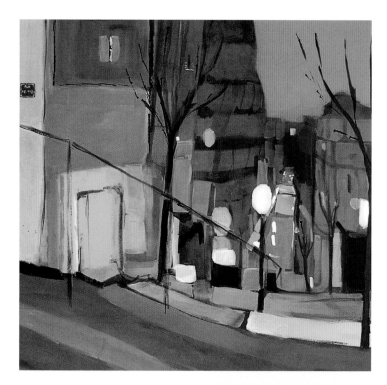

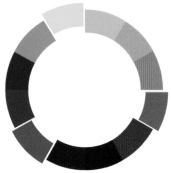

The atmosphere of this picture is created by the all-pervading red of the underpainting. Even the greens and blues are brought back toward the warm end of the spectrum, with all sorts of subtle purples holding the harmonies of color together to beautifully evoke a mysterious Parisian twilight.

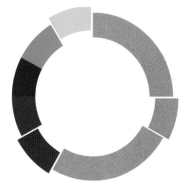

This detailed scene contains a wealth of texture and modeling, but the dominant color note is the cool gray of the cock bird's back. In combination with the bright yellow greens and the blue gray of the rocks, it hardly leaves the cool blue end of the palette, except for the blush of sienna on the bird's throat.

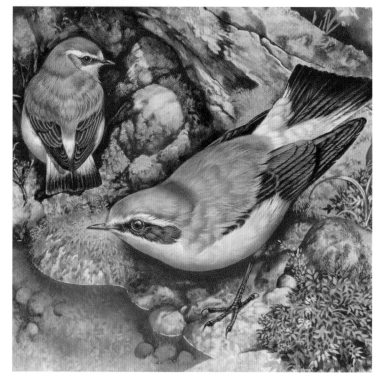

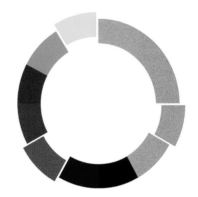

The woodland trees in winter filter the weak sunlight into patches on the forest path. A dominant motif of thin vertical lines gives the picture a feeling of repose, and the blurring of the trunks by the low sun adds the element of infinity.

Ultramarine and raw umber keep all the tints cool, and weak yellow ocher warms the snow color where the sun penetrates the mist. This painting amply demonstrates the value of using only a restricted palette of colors in some of your works.

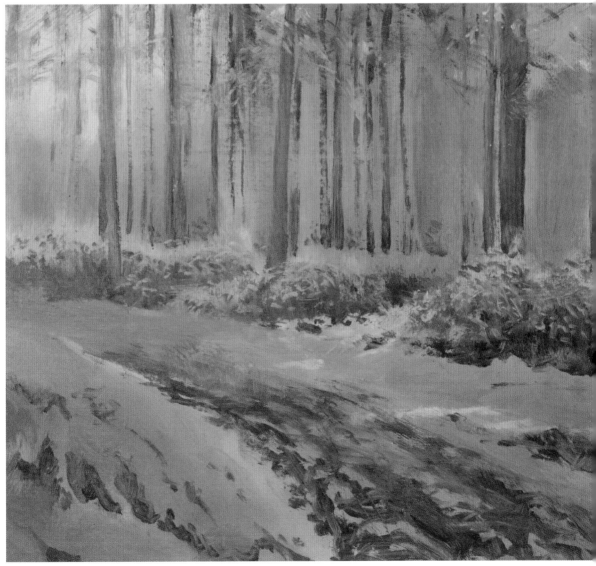

oil color harmonies

The yellow-green-blue range from the color wheel saturates the scene, and it is the bright, almost pure cadmium lemon spots that add the sparkle and interest. The appearance of the burnt sienna in the foreground accentuates the greens.

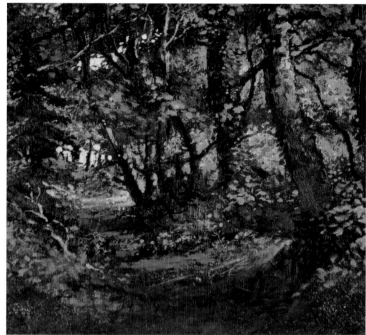

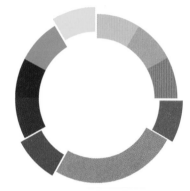

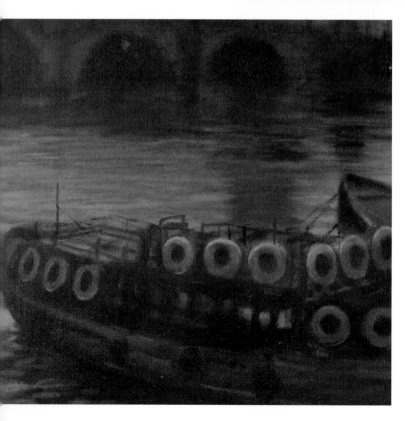

These barges on the Thames below Westminster Bridge act as a foil to the sparkling water painted in a range of closely related cool colors, with hints of the sun's warmth in the pinks. Here the violet and permanent rose from the color wheel provide a range of tints for the reflections that influence the color temperature throughout the picture.

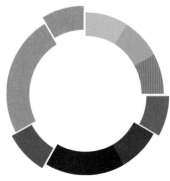

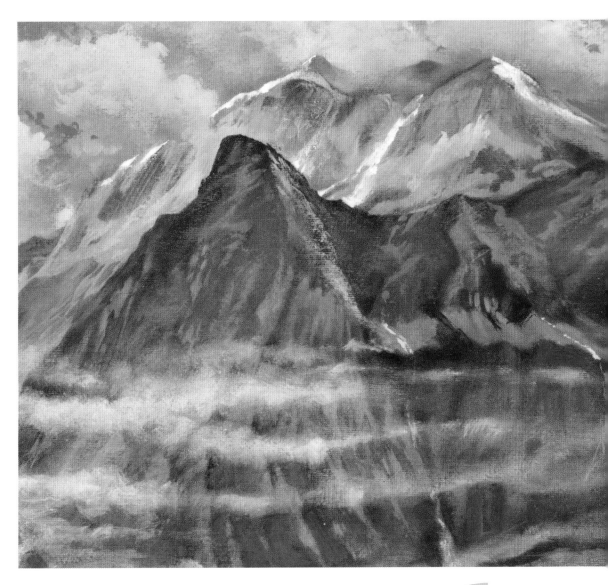

The Wildstrübel, which translates as "tousled head" because the mountain always seems to have a wreath of clouds around its peak, was painted from a mountain house across the valley. In contrast to the Thames painting, the light and air are crystal clear and the whole range of blues and violets crisp and defined in clear patches. The clouds rising from the valley floor were scumbled on after the rest of the picture was dry, a technique often needed in this sort of oil painting to avoid blurring existing details.

watercolor mixes

The following pages feature 25 main watercolors that are the most popular with amateur and professional artists. The mixes provide excellent evidence of how few colors a painter actually needs to produce bright, vibrant colors. Use these mixes as guides to help you achieve the exact shade you want, whatever your subject.

papers and brushes

Storing your brushes upright resting on the handle will keep the bristles in good condition. If treated well, brushes will last for many years.

Watercolor painting requires very little equipment: pan or tube paints, sable or synthetic brushes, good paper, and clean water. In watercolor, fine pigments produce clear, bright washes that can be modified by the slightest amount of other colors. This gives the medium great subtlety and flexibility, but if the water in your jar is tinted, then all your colors are being mixed with that tint, however pale it is. It may not be particularly noticeable to you, but it is happening. The ideal solution is to use two large clear jars so that you can see how much the water is colored, using one to wash your brushes and the other to add water to your colors. In practice, most artists use only one jar, particularly when painting outdoors, and change the water frequently.

To ensure the greatest color accuracy, all the color patches in this book were mixed with clean boiled water and a brush washed under the tap when each patch was finished, until the water ran clear.

WATERCOLOR PAPERS

The paper you choose will have a great influence on the way your paints work, and it is advisable to try a selection before investing in large pads of one type of paper. The surface preferred by many artists is a good-quality rough (or "Not") watercolor paper, but much fine work has been done on papers and boards that were not originally intended as a painting surface. Tinted papers can also be used. On these the contrast between colors will be weaker, as every transparent wash will show some of the paper's own color through it. J.M.W. Turner used many types of paper, including writing papers, and had slate-gray paper bound into sketchbooks for his Venice studies. To counter the

darkness of the paper, he added white to his lighter tones. This is now standard practice with artists working on tinted papers. Most of the papers in his sketchbooks have quite smooth surfaces.

BRUSHES

The range of brushes now available is enormous. Pure sable brushes are the highest quality but expensive; combinations of synthetics and sable offer superior quality at an affordable price. A good starting set of brushes for most needs includes pointed sable brushes up to size 14 for tight control and accuracy; a couple of riggers for drawing long continuous lines (these can be synthetic or sable); broad, flat synthetic wash brushes, ½ inch, 1 inch, 2 inches (1 cm, 2.5 cm, and 5 cm); and a mop brush of squirrel hair for wetting the paper and brushing in large areas.

Try out a lot of different paper textures to find out which best suits your style of work. Paint patches of different colors on different surfaces to see how they react.

the watercolor palette

The colors below are the most popular watercolors with professional and amateur artists. They are all available in art stores and via the Internet. Colors included in many preselected paint boxes are also chosen from this range.

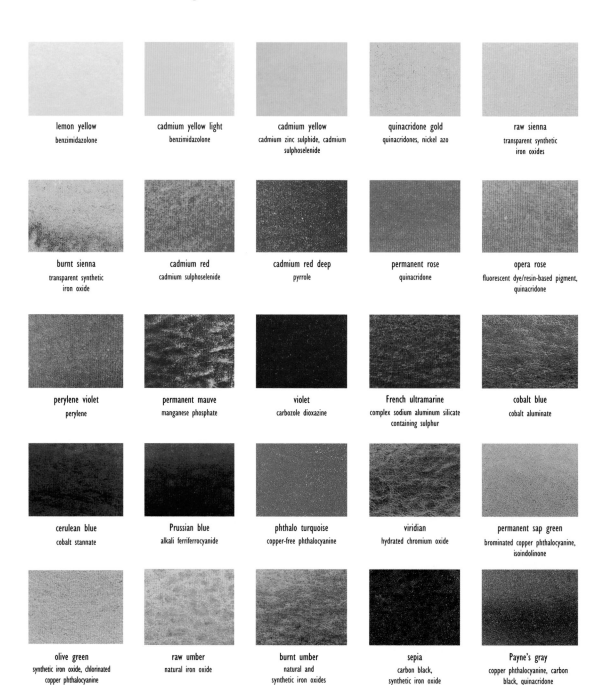

lemon yellow
benzimidazolone

cadmium yellow light
benzimidazolone

cadmium yellow
cadmium zinc sulphide, cadmium
sulphoselenide

quinacridone gold
quinacridones, nickel azo

raw sienna
transparent synthetic
iron oxides

burnt sienna
transparent synthetic
iron oxide

cadmium red
cadmium sulphoselenide

cadmium red deep
pyrrole

permanent rose
quinacridone

opera rose
fluorescent dye/resin-based pigment,
quinacridone

perylene violet
perylene

permanent mauve
manganese phosphate

violet
carbozole dioxazine

French ultramarine
complex sodium aluminum silicate
containing sulphur

cobalt blue
cobalt aluminate

cerulean blue
cobalt stannate

Prussian blue
alkali ferriferrocyanide

phthalo turquoise
copper-free phthalocyanine

viridian
hydrated chromium oxide

permanent sap green
brominated copper phthalocyanine,
isoindolinone

olive green
synthetic iron oxide, chlorinated
copper phthalocyanine

raw umber
natural iron oxide

burnt umber
natural and
synthetic iron oxides

sepia
carbon black,
synthetic iron oxide

Payne's gray
copper phthalocyanine, carbon
black, quinacridone

SUGGESTED PALETTE

It is a good idea for beginners to start with a very restricted palette of six colors and use the charts referring to these six colors to develop their color skills and discover their preferences. They can then augment their palette as they gain experience. A good minimum palette for a beginner is shown here:

cadmium yellow light

cadmium red

French ultramarine

burnt sienna

viridian

violet

Brushes come in many shapes and sizes, but most of those suitable for watercolor are made from sable (or other animal hair) or synthetics.

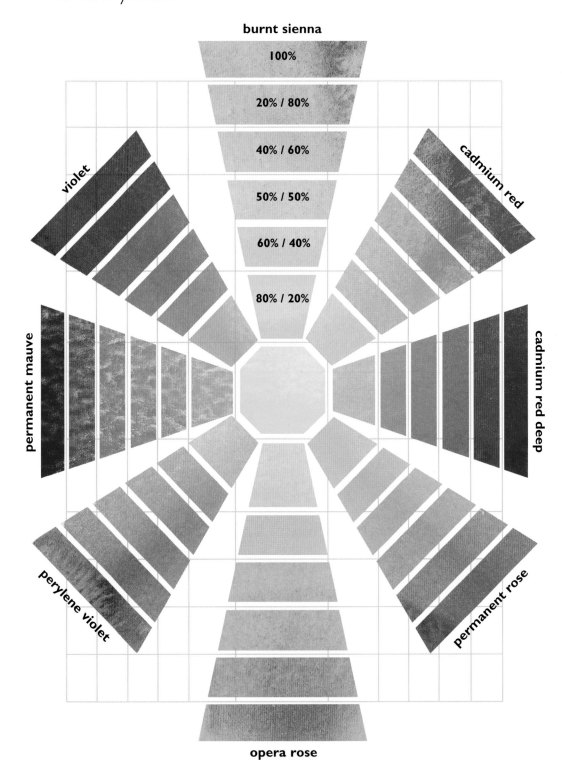

burnt sienna

100%

20% / 80%

40% / 60%

50% / 50%

60% / 40%

80% / 20%

violet

cadmium red

permanent mauve

cadmium red deep

perylene violet

permanent rose

opera rose

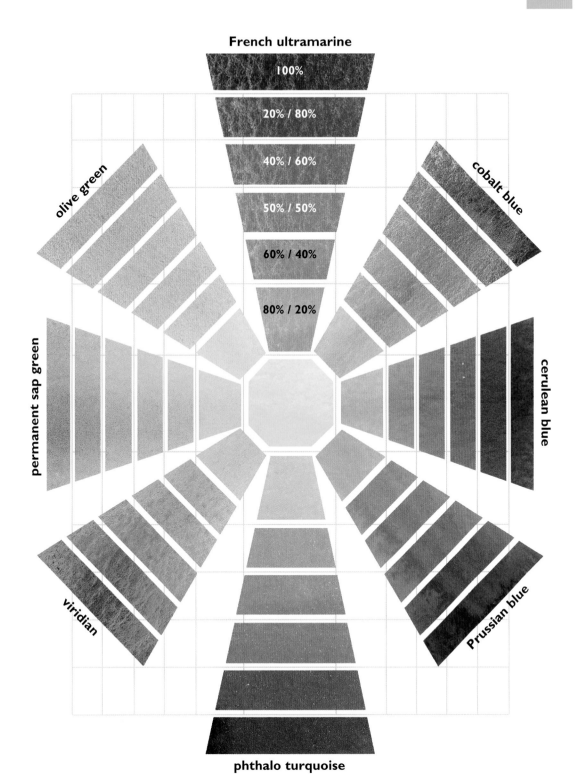

French ultramarine

100%

20% / 80%

40% / 60%

50% / 50%

60% / 40%

80% / 20%

olive green

cobalt blue

permanent sap green

cerulean blue

viridian

Prussian blue

phthalo turquoise

cadmium yellow light

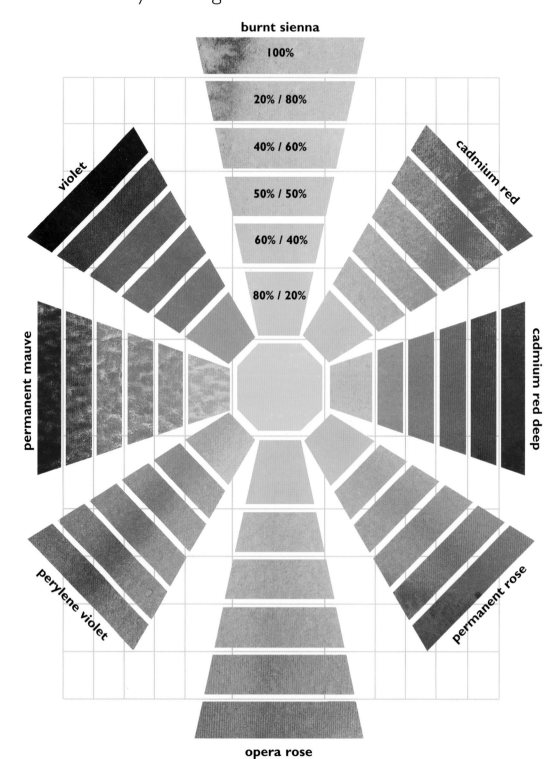

burnt sienna

100%

20% / 80%

40% / 60%

50% / 50%

60% / 40%

80% / 20%

violet

cadmium red

permanent mauve

cadmium red deep

perylene violet

permanent rose

opera rose

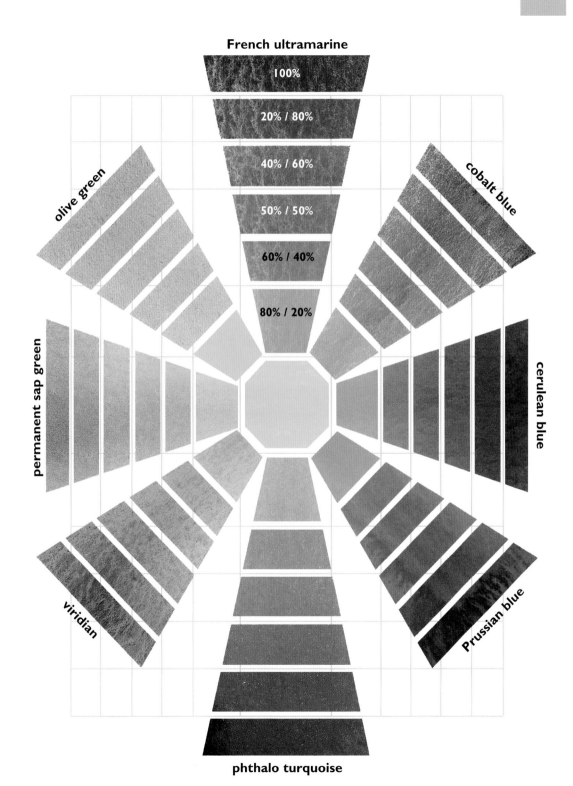

French ultramarine

100%

20% / 80%

40% / 60%

50% / 50%

60% / 40%

80% / 20%

olive green

cobalt blue

permanent sap green

cerulean blue

viridian

Prussian blue

phthalo turquoise

cadmium yellow

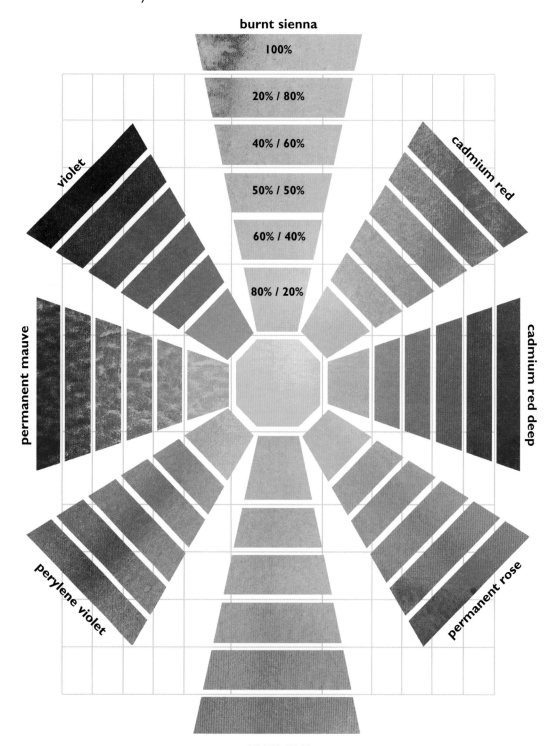

burnt sienna

100%

20% / 80%

40% / 60%

50% / 50%

60% / 40%

80% / 20%

violet

cadmium red

permanent mauve

cadmium red deep

perylene violet

permanent rose

opera rose

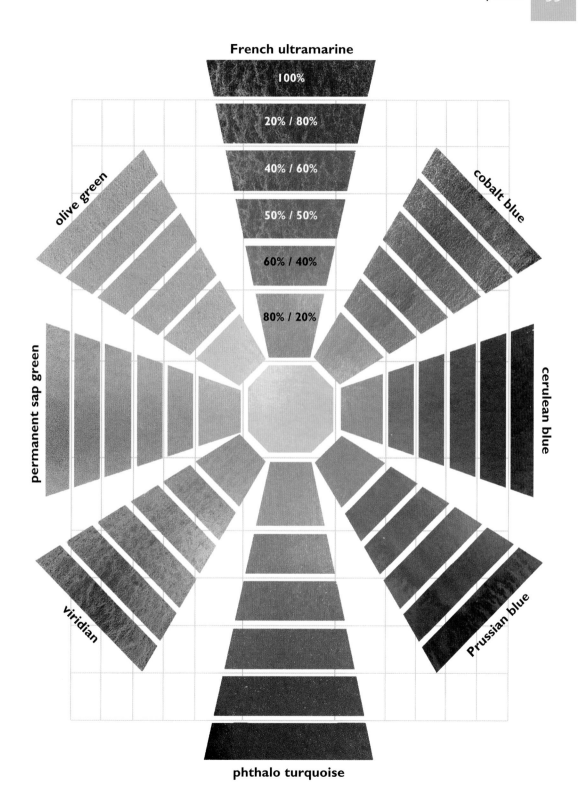

French ultramarine

100%

20% / 80%

40% / 60%

50% / 50%

60% / 40%

80% / 20%

olive green

cobalt blue

permanent sap green

cerulean blue

viridian

Prussian blue

phthalo turquoise

quinacridone gold

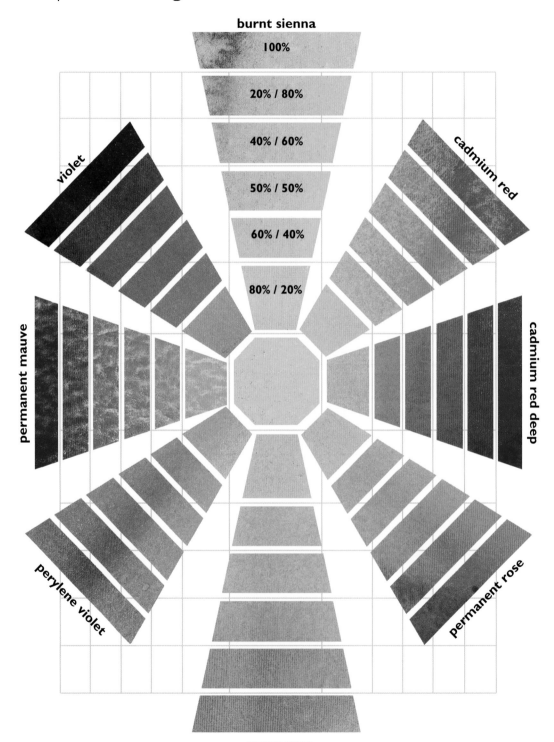

burnt sienna

100%

20% / 80%

40% / 60%

50% / 50%

60% / 40%

80% / 20%

violet

cadmium red

permanent mauve

cadmium red deep

perylene violet

permanent rose

opera rose

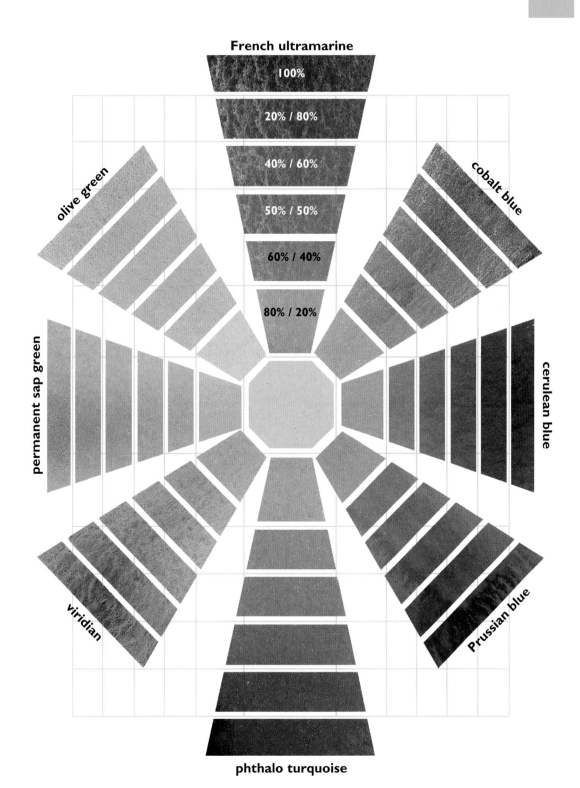

French ultramarine

100%

20% / 80%

40% / 60%

50% / 50%

60% / 40%

80% / 20%

olive green

cobalt blue

permanent sap green

cerulean blue

viridian

Prussian blue

phthalo turquoise

raw sienna

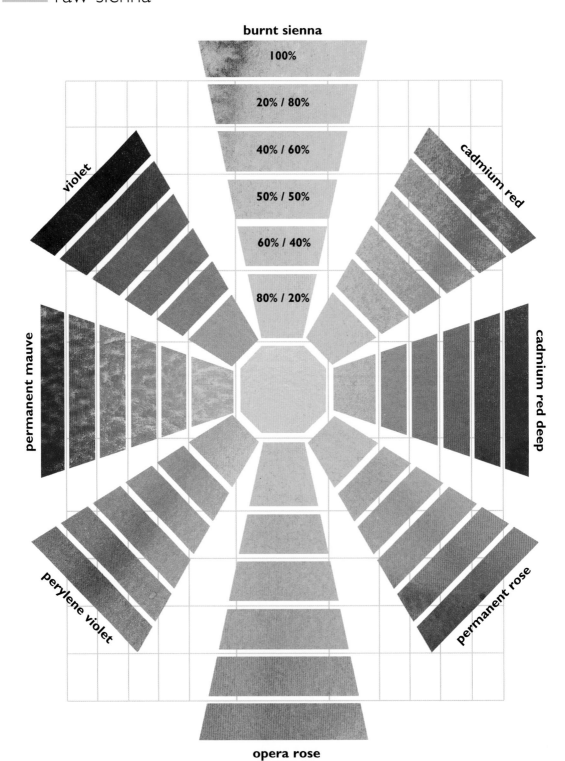

burnt sienna

100%

20% / 80%

40% / 60%

50% / 50%

60% / 40%

80% / 20%

violet

cadmium red

permanent mauve

cadmium red deep

perylene violet

permanent rose

opera rose

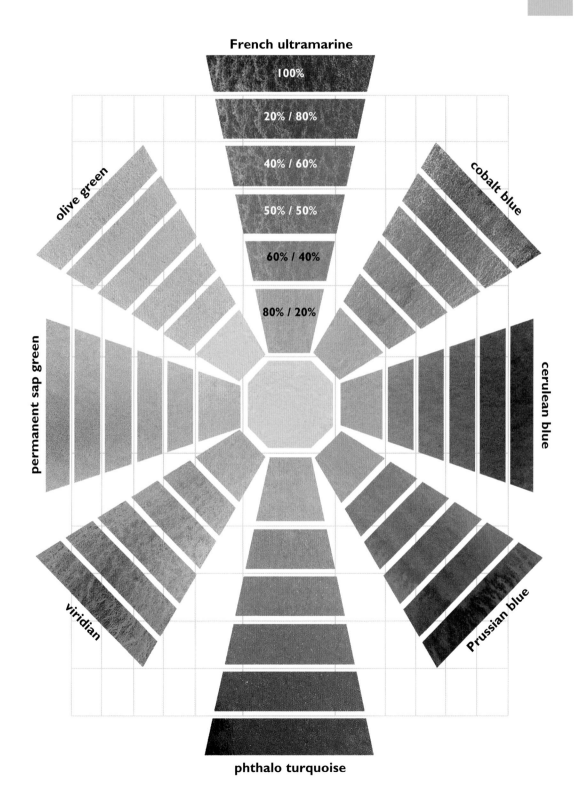

French ultramarine

100%

20% / 80%

40% / 60%

50% / 50%

60% / 40%

80% / 20%

olive green

cobalt blue

permanent sap green

cerulean blue

viridian

Prussian blue

phthalo turquoise

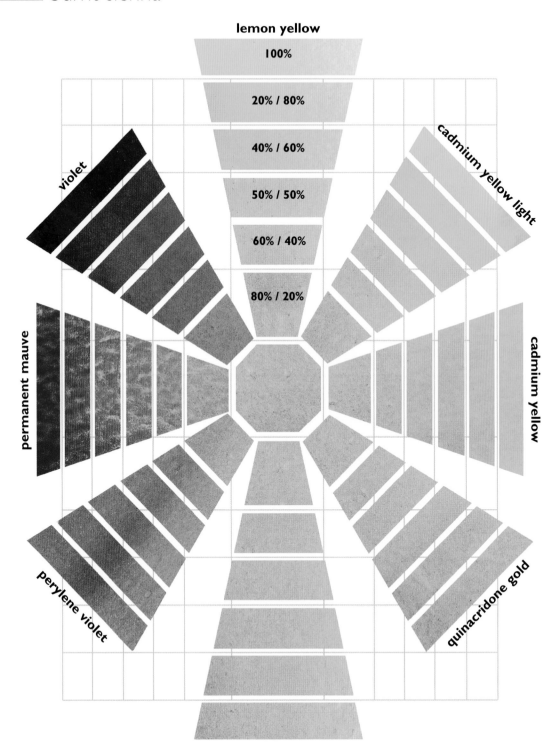

lemon yellow

100%

20% / 80%

40% / 60%

50% / 50%

60% / 40%

80% / 20%

violet

cadmium yellow light

permanent mauve

cadmium yellow

perylene violet

quinacridone gold

raw sienna

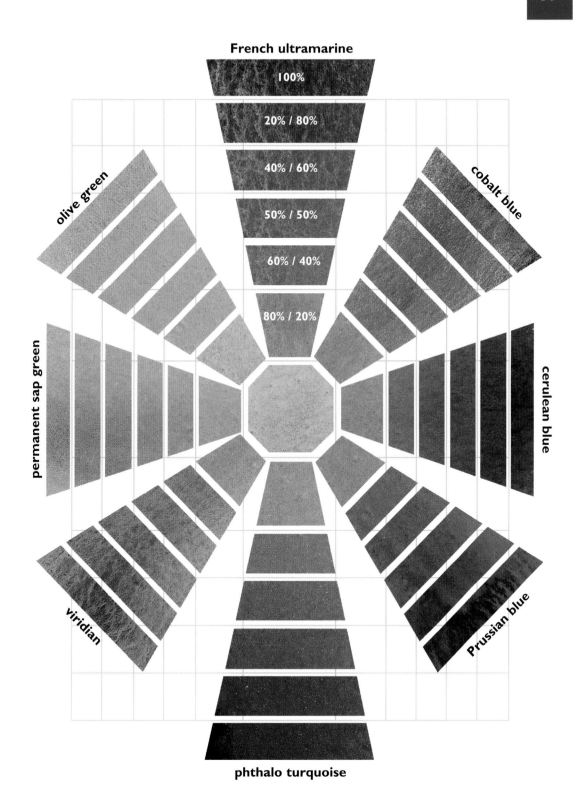

French ultramarine

100%

20% / 80%

40% / 60%

50% / 50%

60% / 40%

80% / 20%

olive green

cobalt blue

permanent sap green

cerulean blue

viridian

Prussian blue

phthalo turquoise

cadmium red

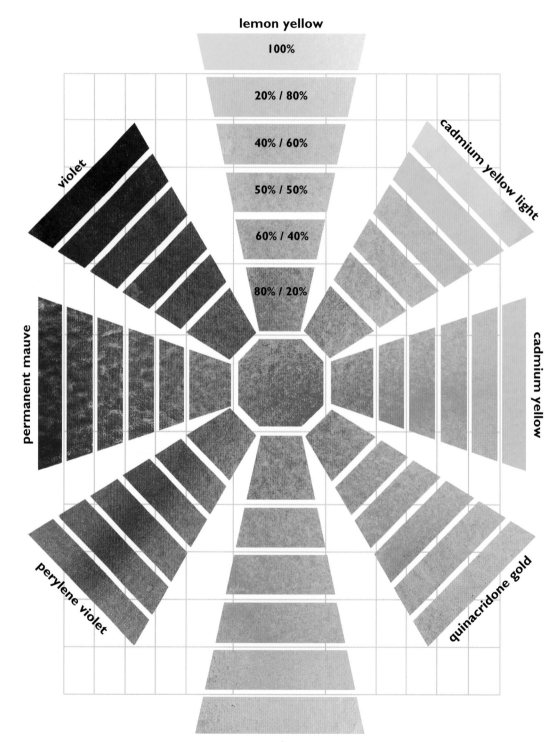

lemon yellow

100%

20% / 80%

40% / 60%

50% / 50%

60% / 40%

80% / 20%

violet

cadmium yellow light

permanent mauve

cadmium yellow

perylene violet

quinacridone gold

raw sienna

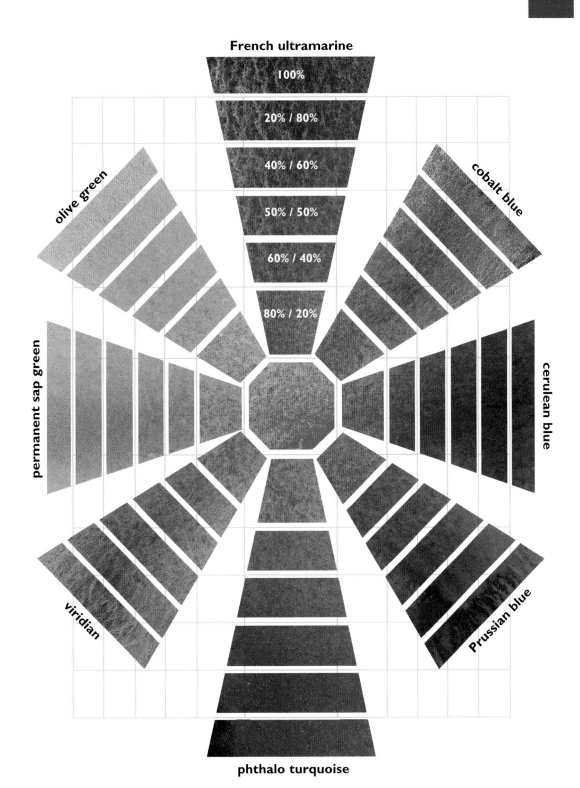

French ultramarine

100%

20% / 80%

40% / 60%

50% / 50%

60% / 40%

80% / 20%

olive green

cobalt blue

permanent sap green

cerulean blue

viridian

Prussian blue

phthalo turquoise

cadmium red deep

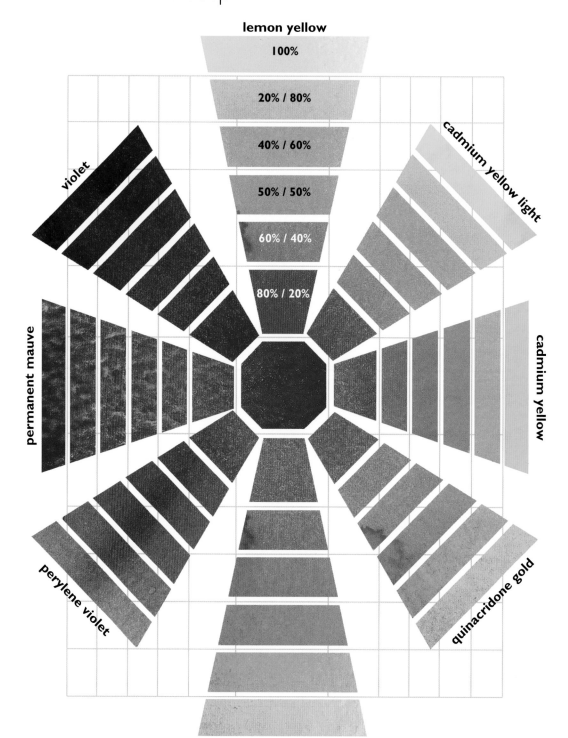

lemon yellow

100%

20% / 80%

40% / 60%

50% / 50%

60% / 40%

80% / 20%

violet

cadmium yellow light

permanent mauve

cadmium yellow

perylene violet

quinacridone gold

raw sienna

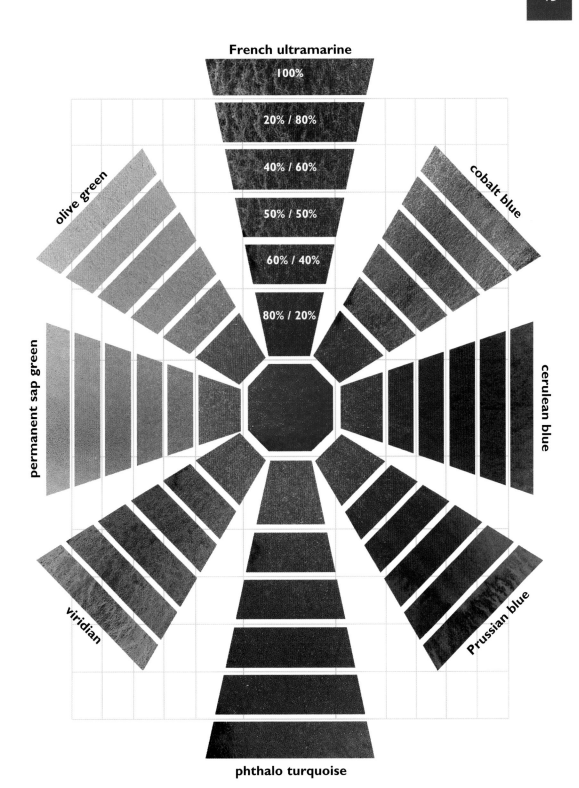

French ultramarine

100%

20% / 80%

40% / 60%

50% / 50%

60% / 40%

80% / 20%

olive green

cobalt blue

permanent sap green

cerulean blue

viridian

Prussian blue

phthalo turquoise

permanent rose

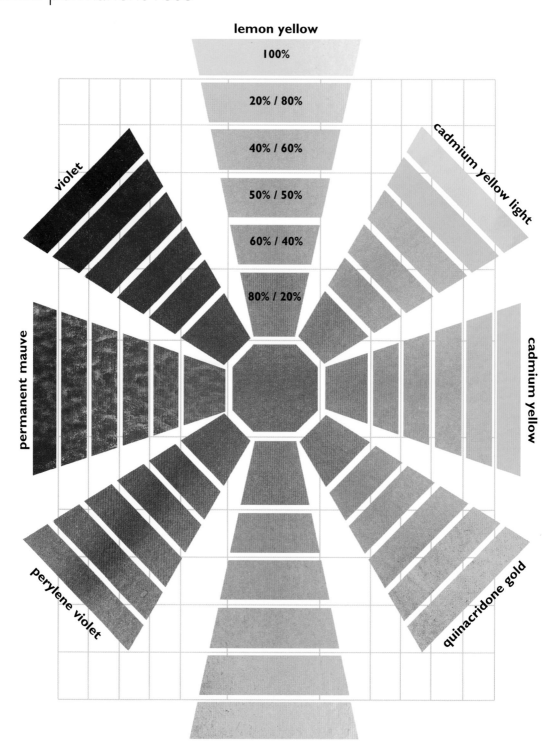

lemon yellow

100%

20% / 80%

40% / 60%

50% / 50%

60% / 40%

80% / 20%

violet

cadmium yellow light

permanent mauve

cadmium yellow

perylene violet

quinacridone gold

raw sienna

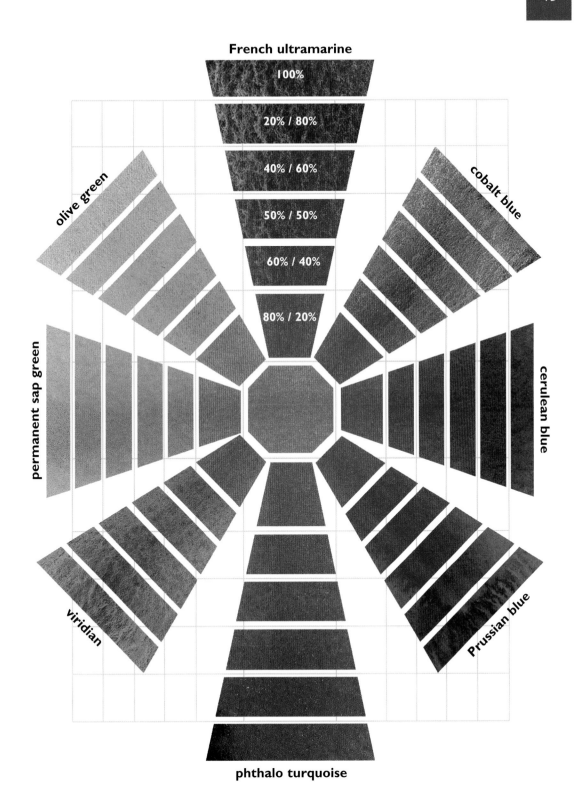

French ultramarine

100%

20% / 80%

40% / 60%

50% / 50%

60% / 40%

80% / 20%

olive green

cobalt blue

permanent sap green

cerulean blue

viridian

Prussian blue

phthalo turquoise

opera rose

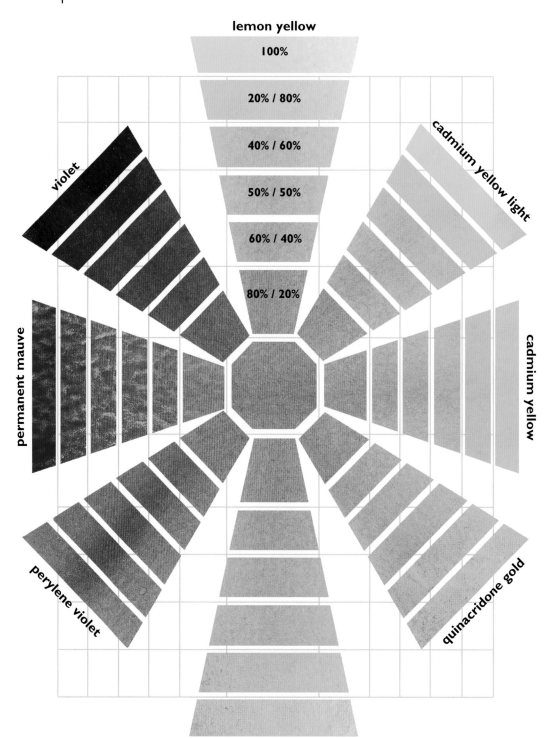

lemon yellow

100%

20% / 80%

40% / 60%

50% / 50%

60% / 40%

80% / 20%

violet

cadmium yellow light

permanent mauve

cadmium yellow

perylene violet

quinacridone gold

raw sienna

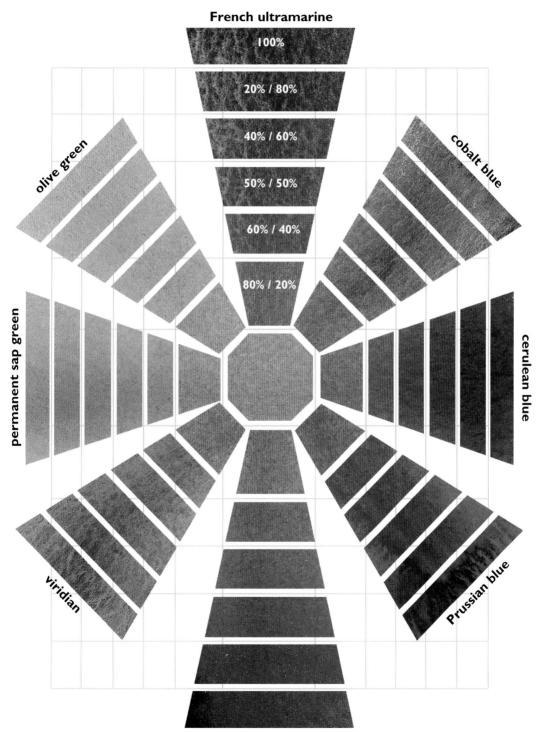

French ultramarine

100%

20% / 80%

40% / 60%

50% / 50%

60% / 40%

80% / 20%

olive green

cobalt blue

permanent sap green

cerulean blue

viridian

Prussian blue

phthalo turquoise

perylene violet

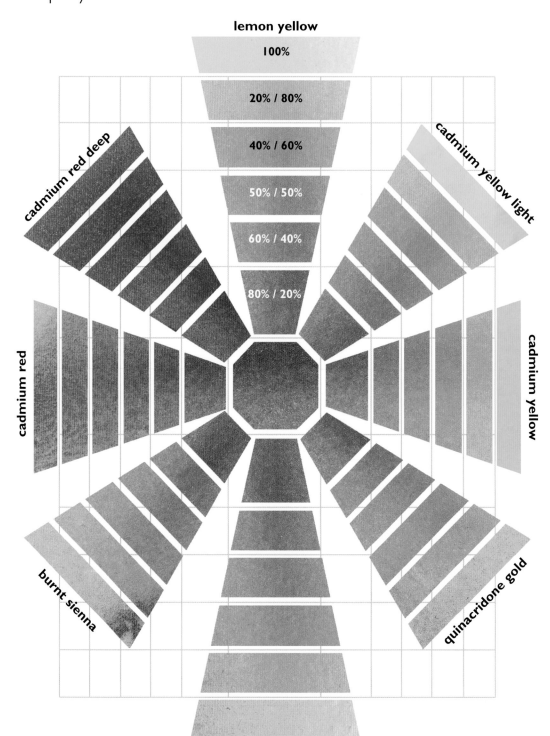

lemon yellow

100%

20% / 80%

40% / 60%

50% / 50%

60% / 40%

80% / 20%

cadmium red deep

cadmium yellow light

cadmium red

cadmium yellow

burnt sienna

quinacridone gold

raw sienna

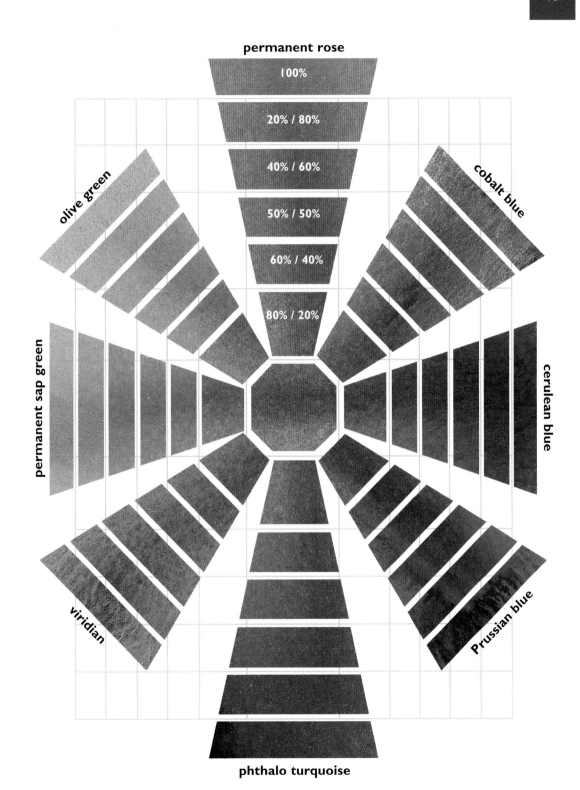

permanent rose

100%

20% / 80%

40% / 60%

50% / 50%

60% / 40%

80% / 20%

olive green

cobalt blue

permanent sap green

cerulean blue

viridian

Prussian blue

phthalo turquoise

permanent mauve

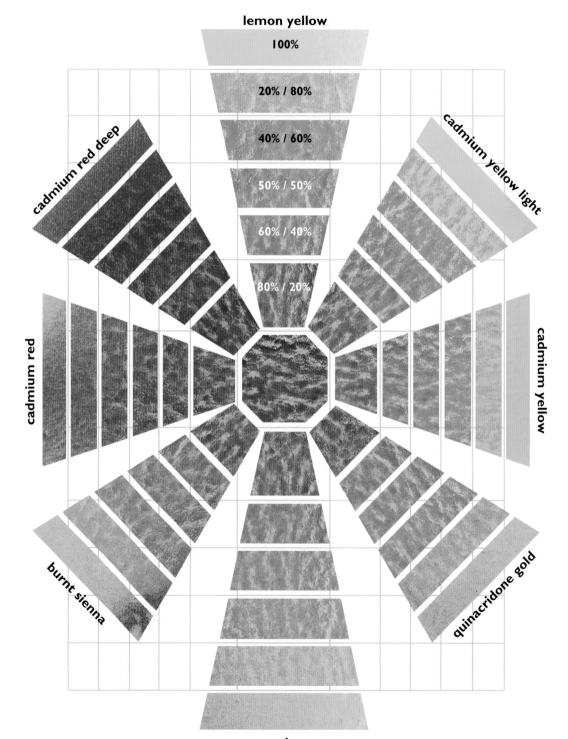

lemon yellow

100%

20% / 80%

40% / 60%

50% / 50%

60% / 40%

80% / 20%

cadmium red deep

cadmium yellow light

cadmium red

cadmium yellow

burnt sienna

quinacridone gold

raw sienna

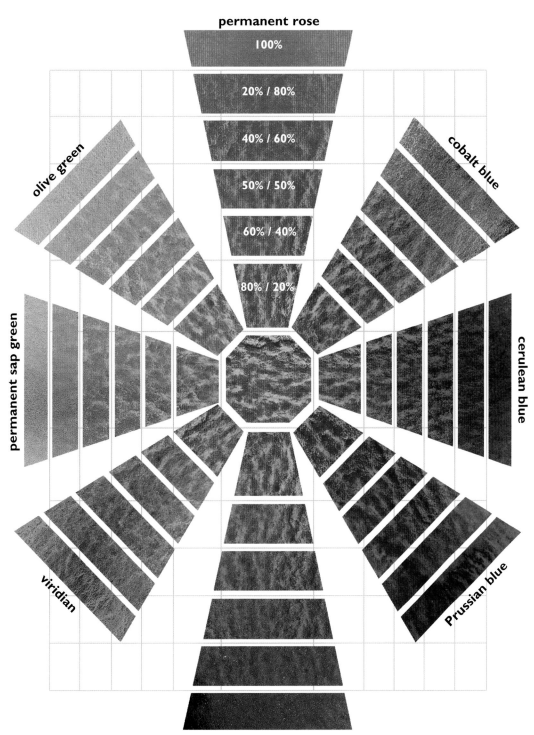

permanent rose

100%

20% / 80%

40% / 60%

50% / 50%

60% / 40%

80% / 20%

olive green

cobalt blue

permanent sap green

cerulean blue

viridian

Prussian blue

phthalo turquoise

lemon yellow

100%

20% / 80%

40% / 60%

50% / 50%

60% / 40%

80% / 20%

cadmium red deep

cadmium yellow light

cadmium red

cadmium yellow

burnt sienna

quinacridone gold

raw sienna

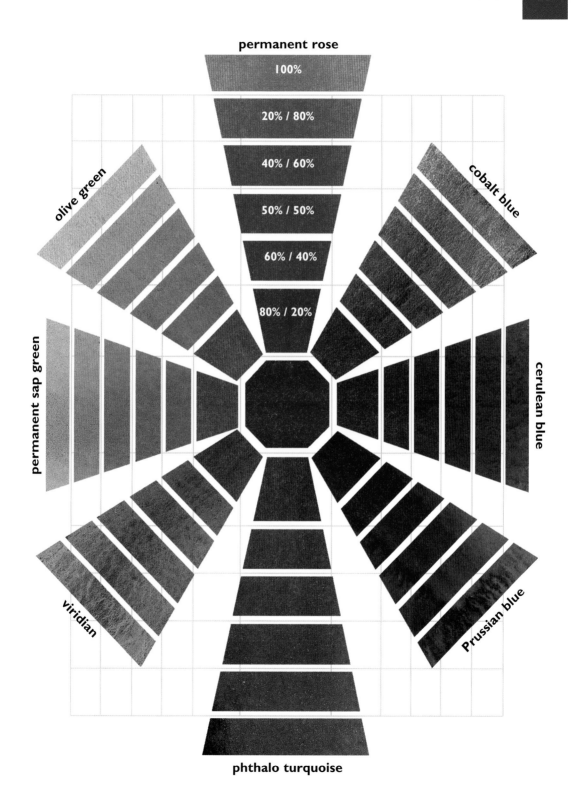

permanent rose

100%

20% / 80%

40% / 60%

50% / 50%

60% / 40%

80% / 20%

olive green

cobalt blue

permanent sap green

cerulean blue

viridian

Prussian blue

phthalo turquoise

French ultramarine

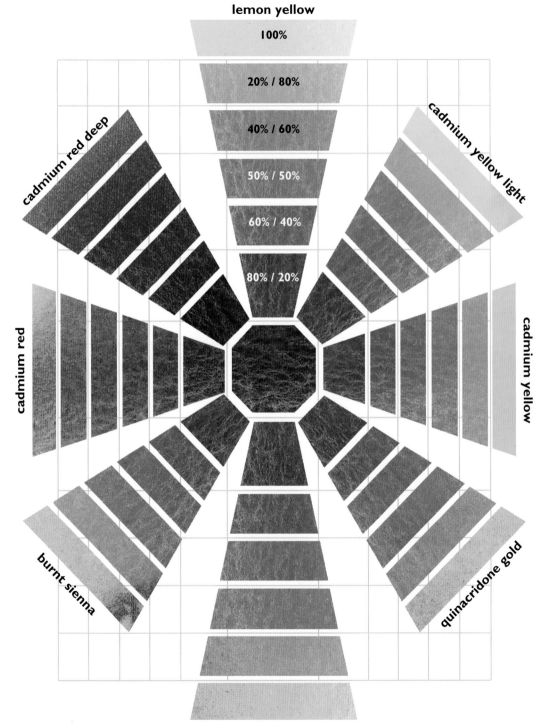

lemon yellow

100%

20% / 80%

40% / 60%

50% / 50%

60% / 40%

80% / 20%

cadmium red deep

cadmium yellow light

cadmium red

cadmium yellow

burnt sienna

quinacridone gold

raw sienna

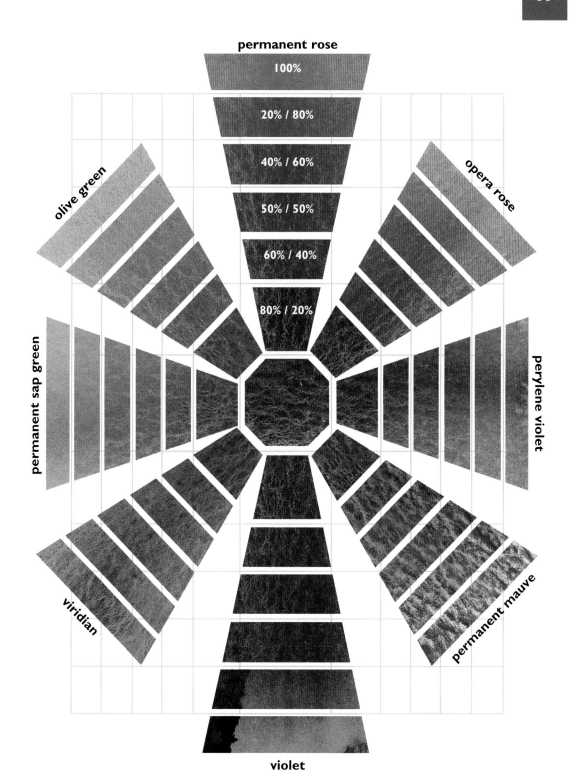

permanent rose

100%

20% / 80%

40% / 60%

50% / 50%

60% / 40%

80% / 20%

olive green

opera rose

permanent sap green

perylene violet

viridian

permanent mauve

violet

cobalt blue

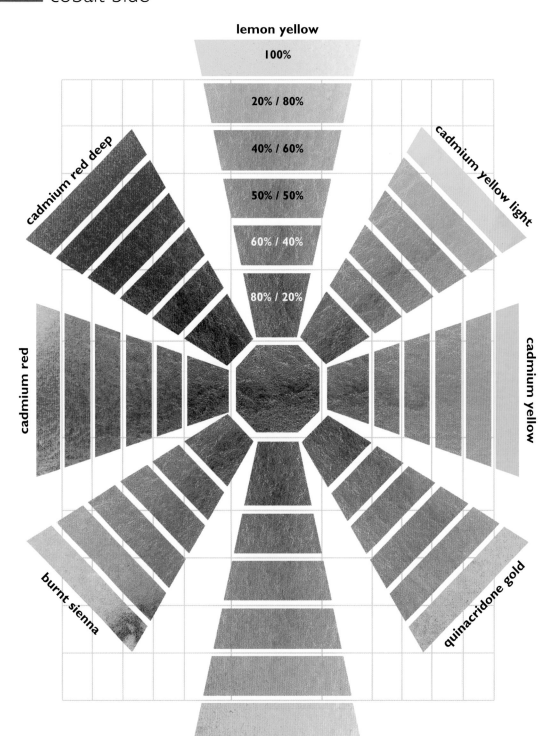

lemon yellow

100%

20% / 80%

40% / 60%

50% / 50%

60% / 40%

80% / 20%

cadmium red deep

cadmium yellow light

cadmium red

cadmium yellow

burnt sienna

quinacridone gold

raw sienna

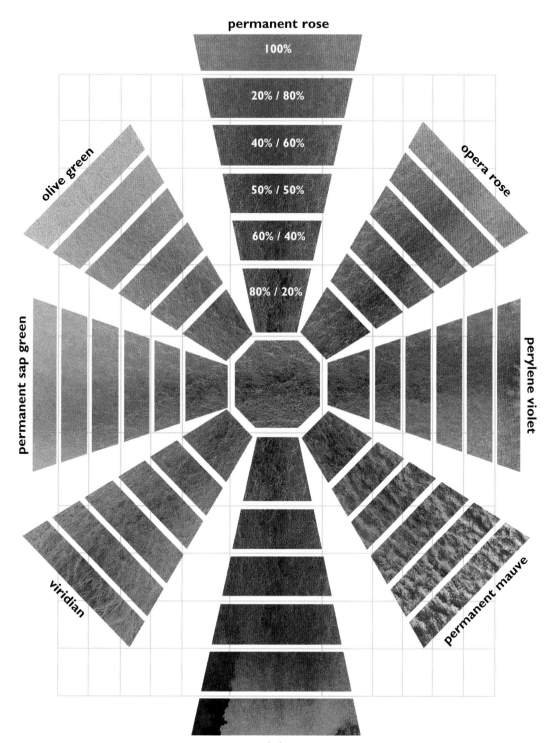

permanent rose

100%

20% / 80%

40% / 60%

50% / 50%

60% / 40%

80% / 20%

olive green

opera rose

permanent sap green

perylene violet

viridian

permanent mauve

violet

cerulean blue

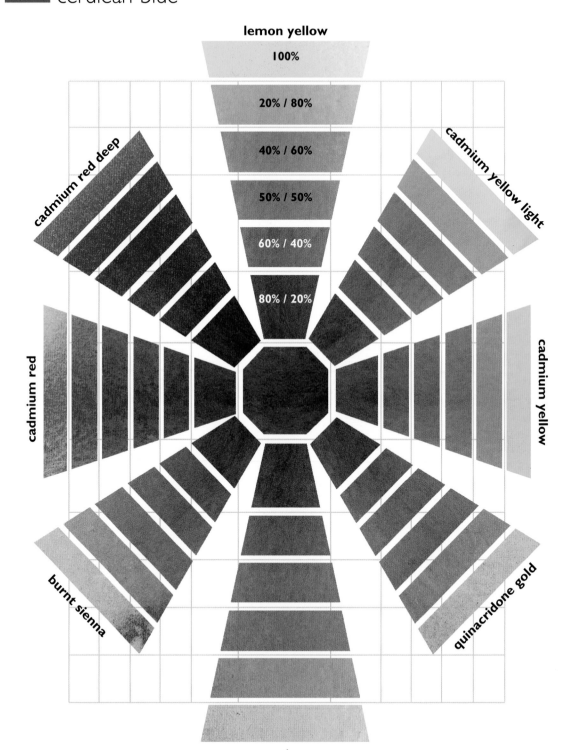

lemon yellow

100%

20% / 80%

40% / 60%

50% / 50%

60% / 40%

80% / 20%

cadmium red deep

cadmium yellow light

cadmium red

cadmium yellow

burnt sienna

quinacridone gold

raw sienna

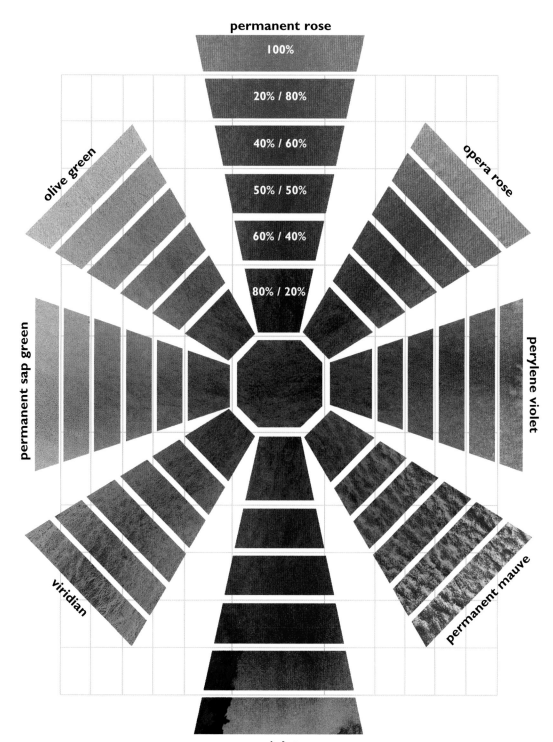

permanent rose

100%

20% / 80%

40% / 60%

50% / 50%

60% / 40%

80% / 20%

olive green

opera rose

permanent sap green

perylene violet

viridian

permanent mauve

violet

Prussian blue

lemon yellow

100%

20% / 80%

40% / 60%

50% / 50%

60% / 40%

80% / 20%

cadmium red deep

cadmium yellow light

cadmium red

cadmium yellow

burnt sienna

quinacridone gold

raw sienna

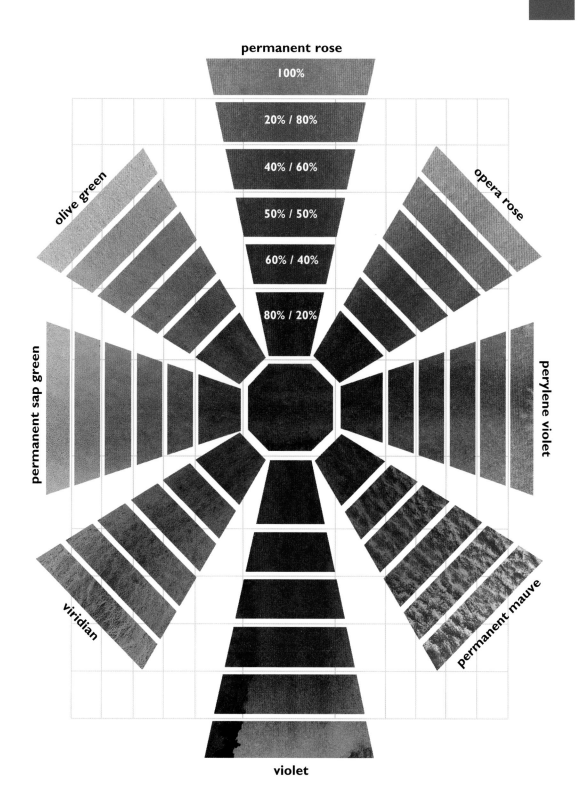

permanent rose

100%

20% / 80%

40% / 60%

50% / 50%

60% / 40%

80% / 20%

olive green

opera rose

permanent sap green

perylene violet

viridian

permanent mauve

violet

phthalo turquoise

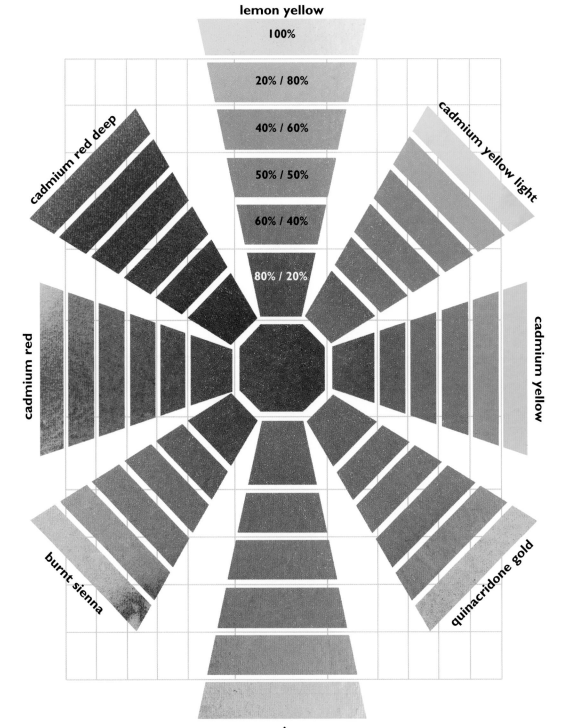

lemon yellow

100%

20% / 80%

40% / 60%

50% / 50%

60% / 40%

80% / 20%

cadmium red deep

cadmium yellow light

cadmium red

cadmium yellow

burnt sienna

quinacridone gold

raw sienna

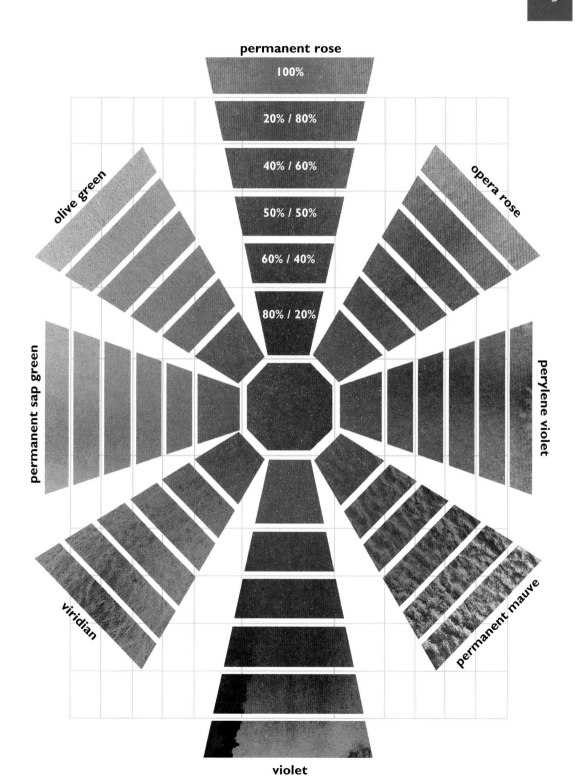

permanent rose

100%

20% / 80%

40% / 60%

50% / 50%

60% / 40%

80% / 20%

olive green

opera rose

permanent sap green

perylene violet

viridian

permanent mauve

violet

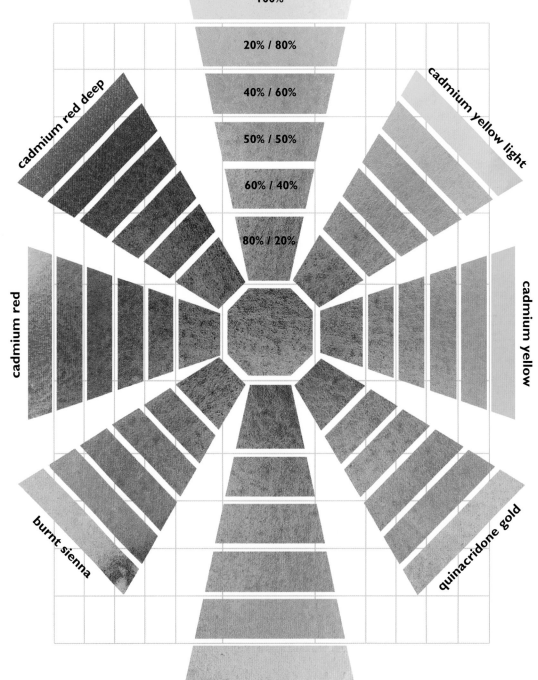

lemon yellow

100%

20% / 80%

40% / 60%

50% / 50%

60% / 40%

80% / 20%

cadmium red deep

cadmium yellow light

cadmium red

cadmium yellow

burnt sienna

quinacridone gold

raw sienna

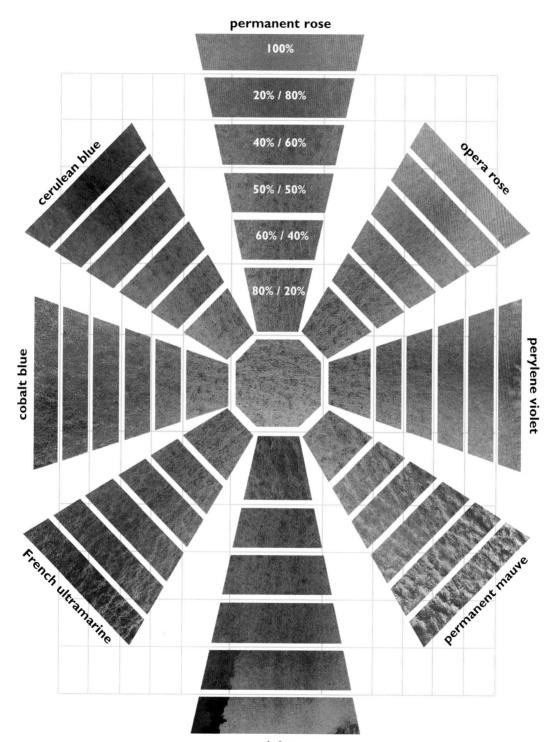

permanent rose

100%

20% / 80%

40% / 60%

50% / 50%

60% / 40%

80% / 20%

cerulean blue

opera rose

cobalt blue

perylene violet

French ultramarine

permanent mauve

violet

permanent sap green

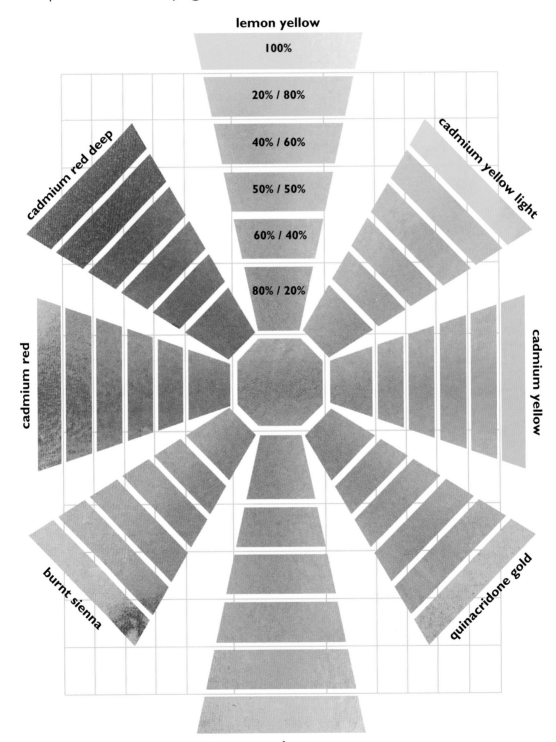

lemon yellow

100%

20% / 80%

40% / 60%

50% / 50%

60% / 40%

80% / 20%

cadmium red deep

cadmium yellow light

cadmium red

cadmium yellow

burnt sienna

quinacridone gold

raw sienna

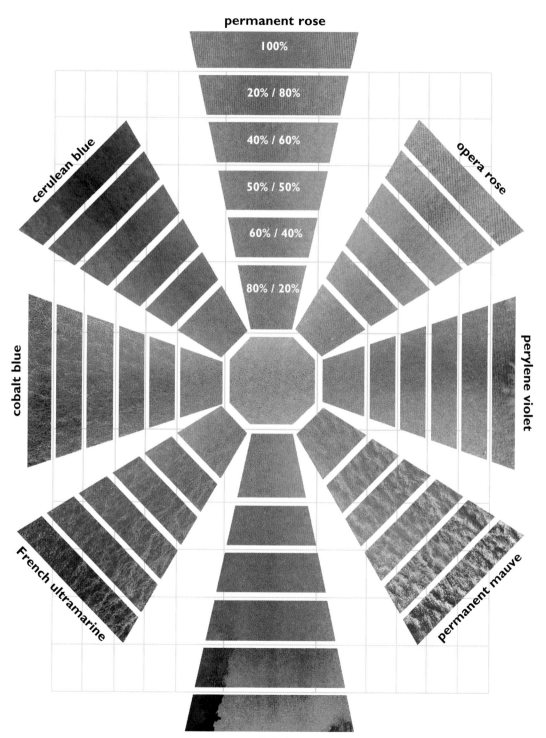

permanent rose

100%

20% / 80%

40% / 60%

50% / 50%

60% / 40%

80% / 20%

cerulean blue

opera rose

cobalt blue

perylene violet

French ultramarine

permanent mauve

violet

olive green

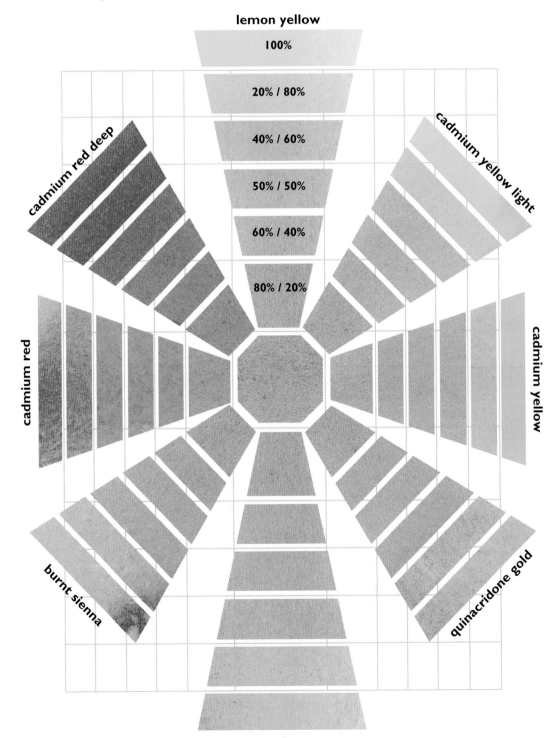

lemon yellow

100%

20% / 80%

40% / 60%

50% / 50%

60% / 40%

80% / 20%

cadmium red deep

cadmium yellow light

cadmium red

cadmium yellow

burnt sienna

quinacridone gold

raw sienna

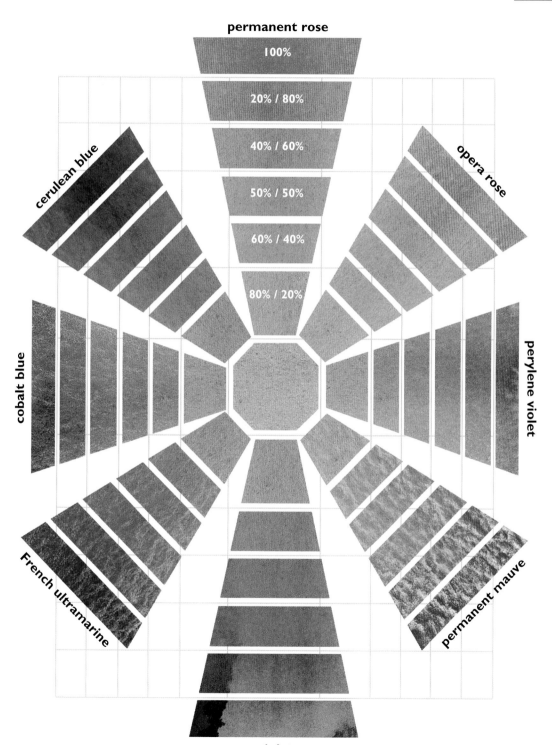

permanent rose

100%

20% / 80%

40% / 60%

50% / 50%

60% / 40%

80% / 20%

cerulean blue

opera rose

cobalt blue

perylene violet

French ultramarine

permanent mauve

violet

raw umber

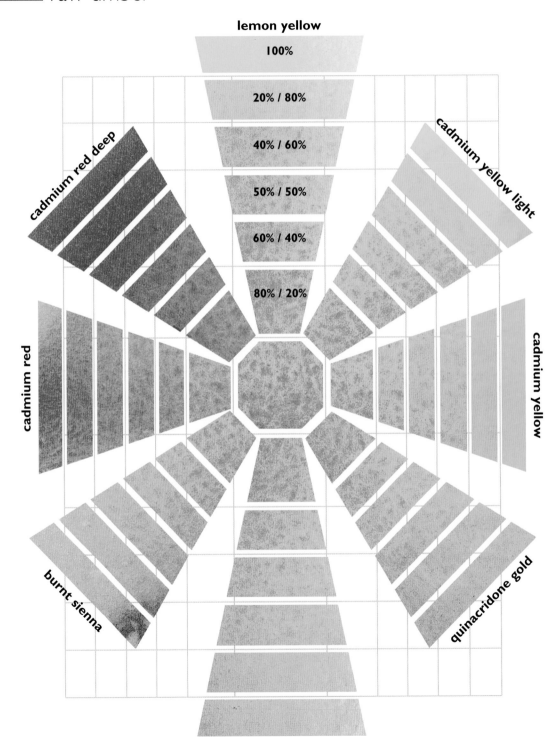

lemon yellow

100%

20% / 80%

40% / 60%

50% / 50%

60% / 40%

80% / 20%

cadmium red deep

cadmium yellow light

cadmium red

cadmium yellow

burnt sienna

quinacridone gold

raw sienna

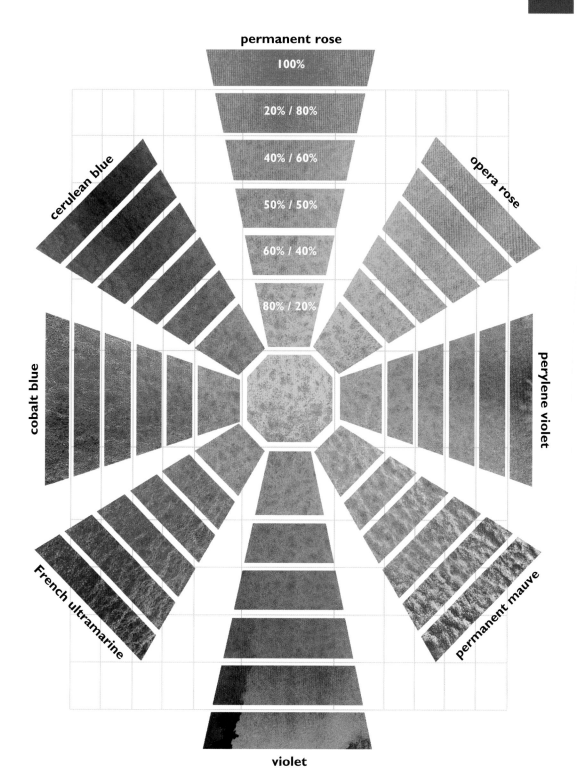

permanent rose

100%

20% / 80%

40% / 60%

50% / 50%

60% / 40%

80% / 20%

cerulean blue

opera rose

cobalt blue

perylene violet

French ultramarine

permanent mauve

violet

burnt umber

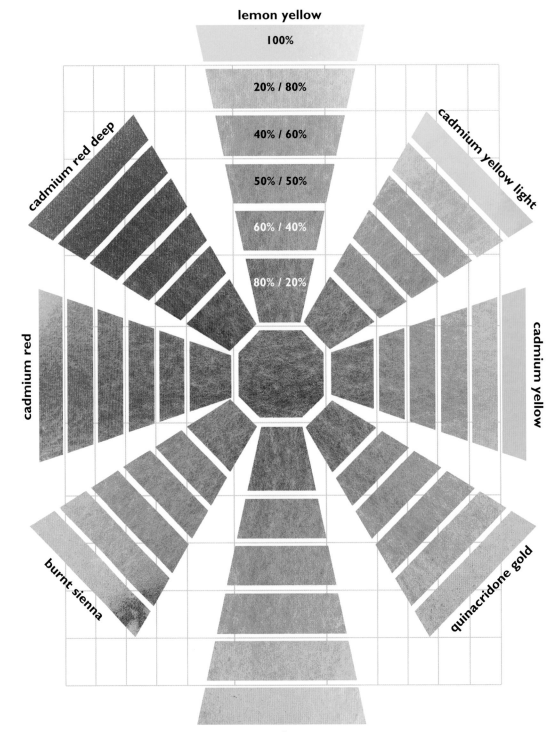

lemon yellow

100%

20% / 80%

40% / 60%

50% / 50%

60% / 40%

80% / 20%

cadmium red deep

cadmium yellow light

cadmium red

cadmium yellow

burnt sienna

quinacridone gold

raw sienna

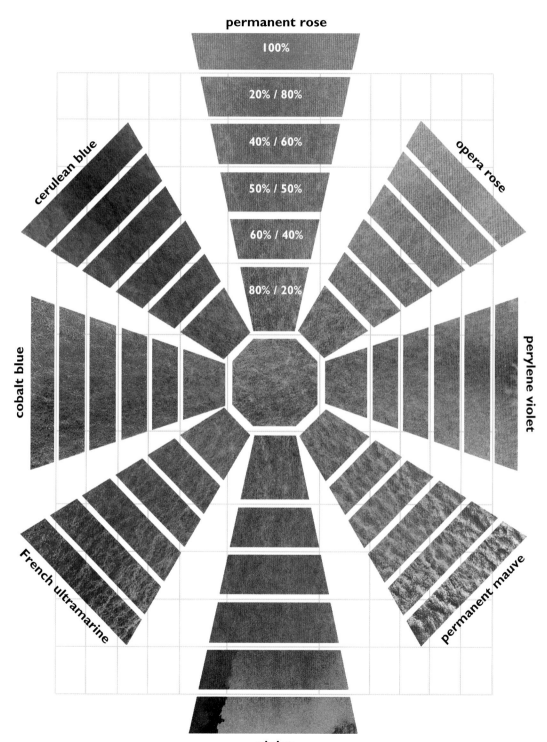

permanent rose

100%

20% / 80%

40% / 60%

50% / 50%

60% / 40%

80% / 20%

cerulean blue

opera rose

cobalt blue

perylene violet

French ultramarine

permanent mauve

violet

sepia

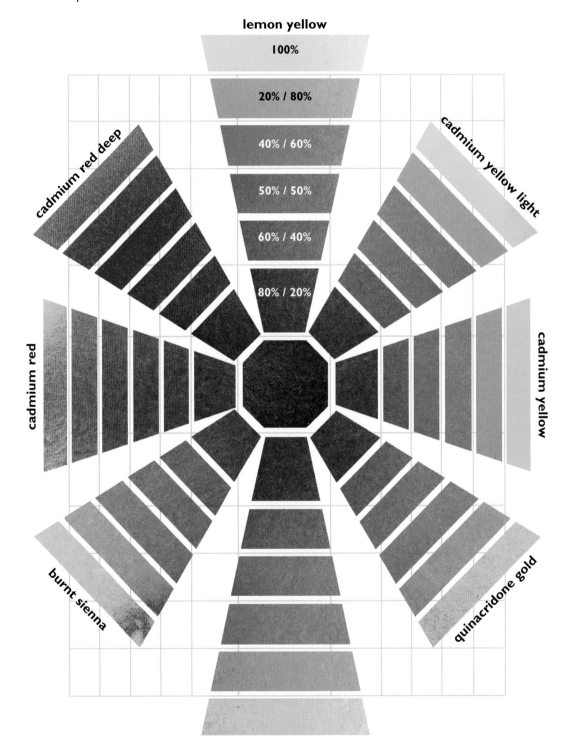

lemon yellow

100%

20% / 80%

40% / 60%

50% / 50%

60% / 40%

80% / 20%

cadmium red deep

cadmium yellow light

cadmium red

cadmium yellow

burnt sienna

quinacridone gold

raw sienna

permanent rose

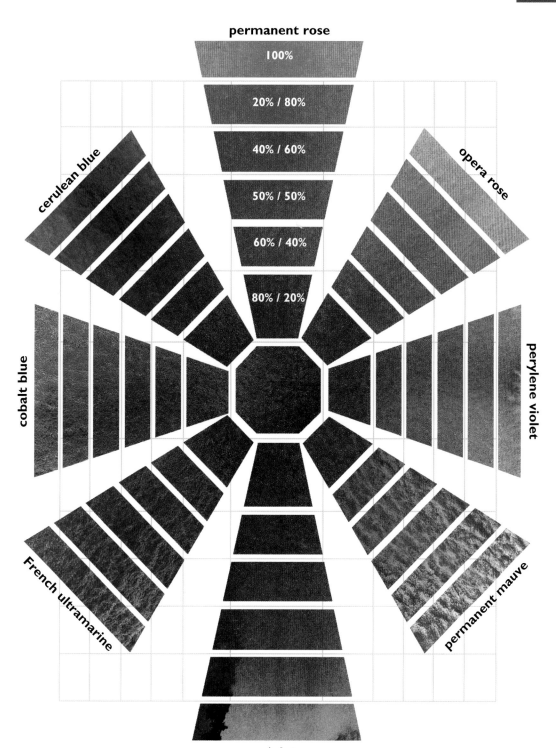

100%

20% / 80%

40% / 60%

50% / 50%

60% / 40%

80% / 20%

cerulean blue

opera rose

cobalt blue

perylene violet

French ultramarine

permanent mauve

violet

Payne's gray

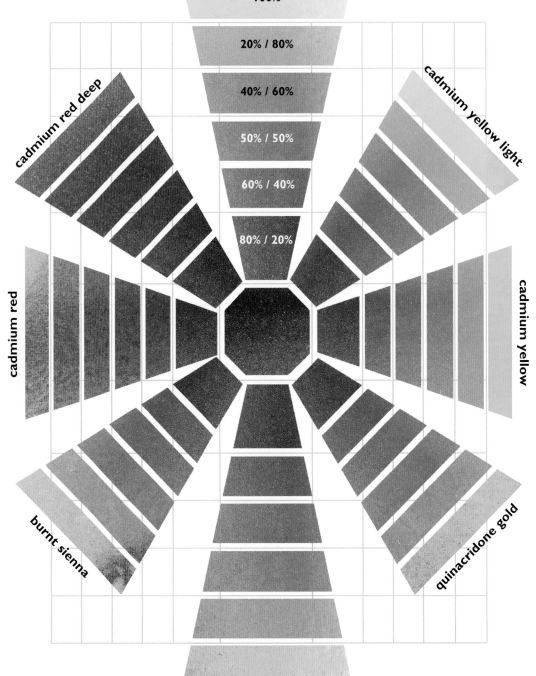

lemon yellow

100%

20% / 80%

40% / 60%

50% / 50%

60% / 40%

80% / 20%

cadmium red deep

cadmium yellow light

cadmium red

cadmium yellow

burnt sienna

quinacridone gold

raw sienna

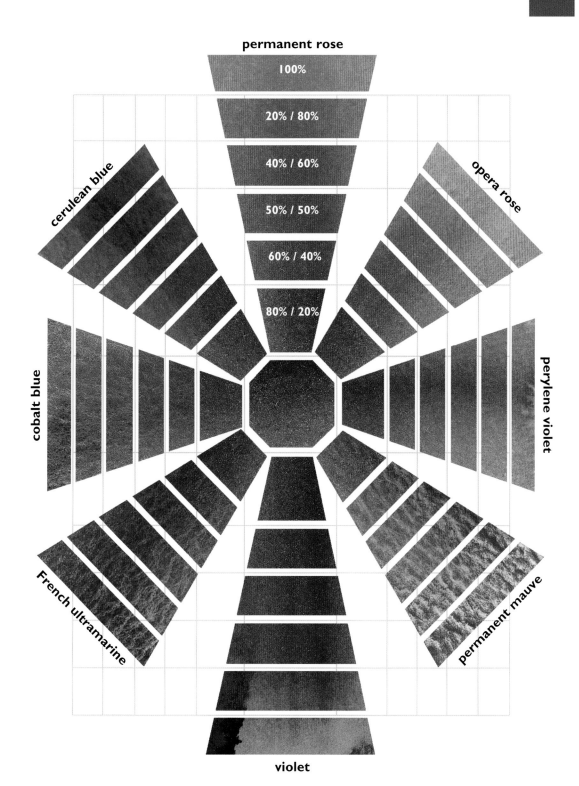

permanent rose

100%

20% / 80%

40% / 60%

50% / 50%

60% / 40%

80% / 20%

cerulean blue

opera rose

cobalt blue

perylene violet

French ultramarine

permanent mauve

violet

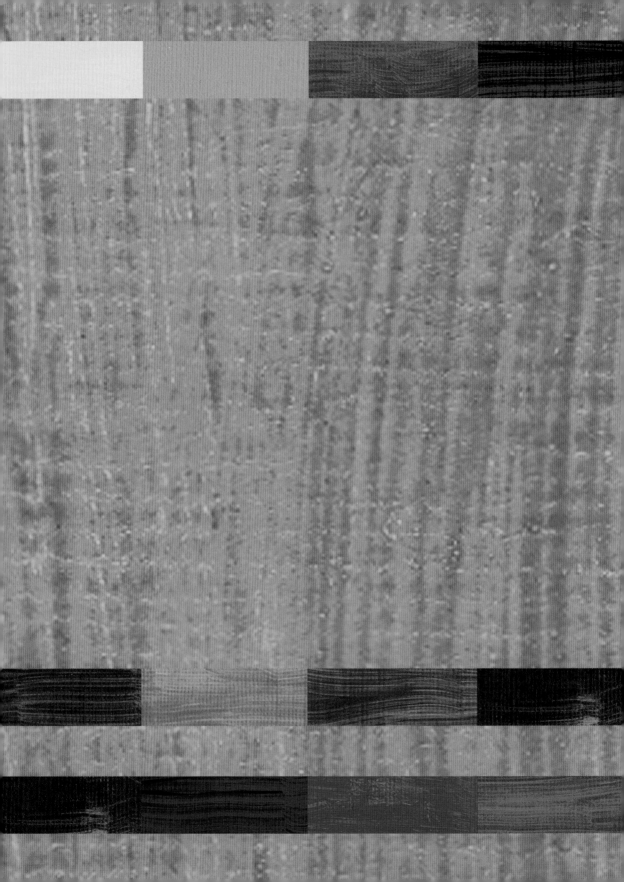

acrylic color mixes

The following pages feature 25 of the most widely used acrylic colors by amateur and professional artists. The mixes provide excellent evidence that you do not need a huge collection of paints to produce a wide range of bright, vibrant colors, whatever your subject. Use these mixes as guides to help you achieve the exact shade you want.

supports and brushes

Painting in acrylics can be done on almost any surface. A surface that has been covered with a brilliant white will give the brightest effects when transparent washes are used. Transparent washes work well on many kinds of paper, including those made for watercolor painting. When the paints are made opaque by the addition of white, the color of the ground becomes less important.

Canvas, paper, card stock, hardboard, MDF (medium-density fiberboard), unglazed ceramics, and even nonferrous metal, as long as it has some texture to aid adhesion, can all give good results and make possible a vast range of effects. Acrylics are ideal for mural painting. The advent of acrylics has encouraged experimentation and made painting and craft work easier and more accessible to more people.

An easel is a useful addition to your acrylic painting kit. If you keep all your paints, papers, brushes, and other supports together between sessions, everything you need is readily at hand when you want to paint.

BRUSHES AND TOOLS

Any means of applying paint can be used with acrylics. Usable tools range from the fine sable brushes used for professional illustration to the knives and modeling tools used on textured abstract work, which have expressive possibilities when used with acrylics.

Traditional hog-hair brushes

When selecting brushes choose at least one broad flat brush for laying washes, as well as several different-sized round brushes. Filberts, far right, allow you to produce soft, tapered marks and are good for softening edges.

are excellent for acrylics, as are polyester and synthetic fibers. Rollers can be used in many types of picture making, and a wire brush can even be used to leave furrows and stipple marks in wet paint.

A wide range of brushes made by many manufacturers are specially designed for use with acrylics, and their firm but flexible hairs work well with the traditional styles of painting.

A word of warning: Be scrupulous about washing your brushes immediately after use. Once the chemical drying process has begun, it cannot be reversed. Wash your brushes in clean water until the water runs clear, and ensure that there is no paint left between the hairs near the metal ferrule. Some soap or dishwashing liquid will help you keep your brushes clean and reusable.

Acrylic colors can be used on canvas and, once they are dry, give results comparable to oil colors.

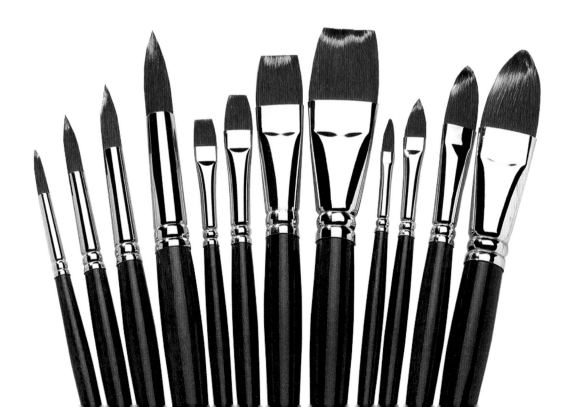

the acrylics palette

These are the most popular acrylics manufactured, available in art stores and via the Internet. Colors included in many preselected paint boxes are also chosen from this range.

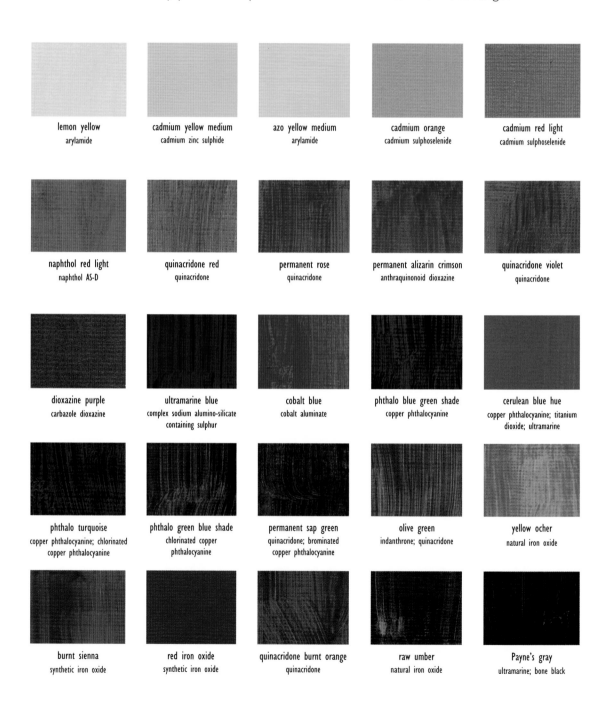

lemon yellow
arylamide

cadmium yellow medium
cadmium zinc sulphide

azo yellow medium
arylamide

cadmium orange
cadmium sulphoselenide

cadmium red light
cadmium sulphoselenide

naphthol red light
naphthol AS-D

quinacridone red
quinacridone

permanent rose
quinacridone

permanent alizarin crimson
anthraquinonoid dioxazine

quinacridone violet
quinacridone

dioxazine purple
carbazole dioxazine

ultramarine blue
complex sodium alumino-silicate
containing sulphur

cobalt blue
cobalt aluminate

phthalo blue green shade
copper phthalocyanine

cerulean blue hue
copper phthalocyanine; titanium
dioxide; ultramarine

phthalo turquoise
copper phthalocyanine; chlorinated
copper phthalocyanine

phthalo green blue shade
chlorinated copper
phthalocyanine

permanent sap green
quinacridone; brominated
copper phthalocyanine

olive green
indanthrone; quinacridone

yellow ocher
natural iron oxide

burnt sienna
synthetic iron oxide

red iron oxide
synthetic iron oxide

quinacridone burnt orange
quinacridone

raw umber
natural iron oxide

Payne's gray
ultramarine; bone black

SUGGESTED PALETTE

It is a good idea for beginners to start with a very restricted palette of six colors and use the charts referring to these six colors to develop their color skills and discover their preferences. They can then augment their palette as they gain experience. A good minimum palette for a beginner is shown here:

cadmium red light

ultramarine blue

lemon yellow

burnt sienna

phthalo green blue shade

dioxazine purple

Acrylic colors are available in a broad range of colors and can be mixed together to create many more shades. Mix in a palette or on a plate to get the precise color you want.

lemon yellow

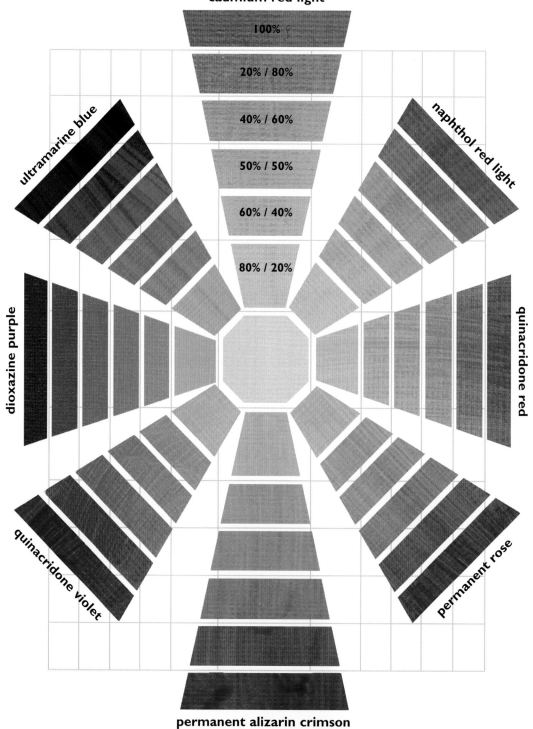

cadmium red light

100%

20% / 80%

40% / 60%

50% / 50%

60% / 40%

80% / 20%

ultramarine blue

naphthol red light

dioxazine purple

quinacridone red

quinacridone violet

permanent rose

permanent alizarin crimson

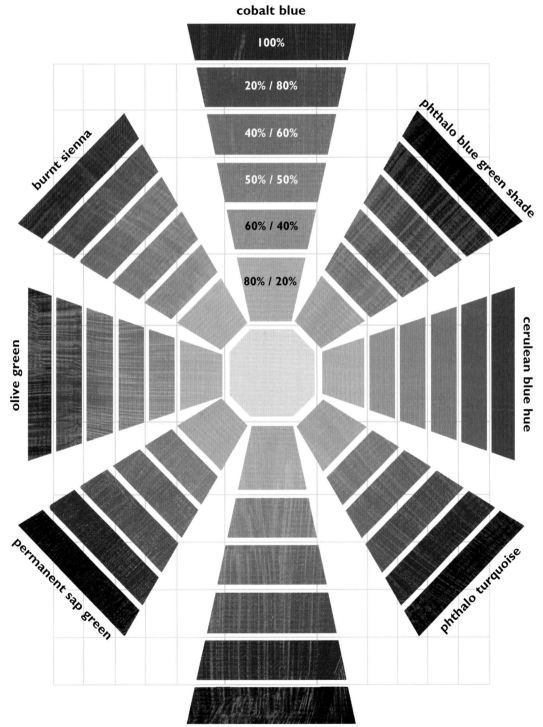

cobalt blue

100%

20% / 80%

40% / 60%

50% / 50%

60% / 40%

80% / 20%

burnt sienna

phthalo blue green shade

olive green

cerulean blue hue

permanent sap green

phthalo turquoise

phthalo green blue shade

cadmium yellow medium

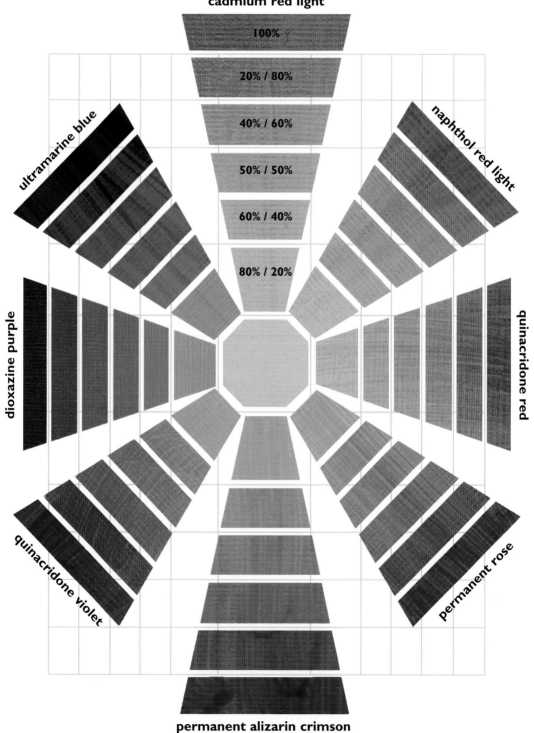

cadmium red light

100%

20% / 80%

40% / 60%

50% / 50%

60% / 40%

80% / 20%

ultramarine blue

naphthol red light

dioxazine purple

quinacridone red

quinacridone violet

permanent rose

permanent alizarin crimson

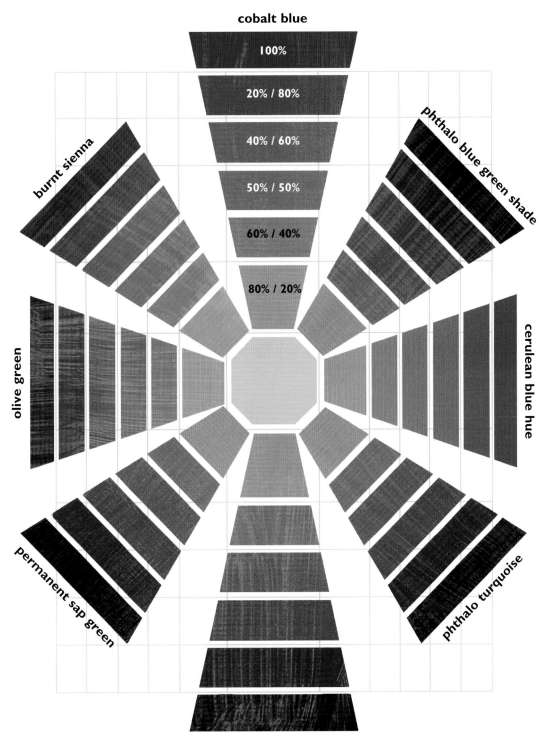

cobalt blue

100%

20% / 80%

40% / 60%

50% / 50%

60% / 40%

80% / 20%

burnt sienna

phthalo blue green shade

olive green

cerulean blue hue

permanent sap green

phthalo turquoise

phthalo green blue shade

azo yellow medium

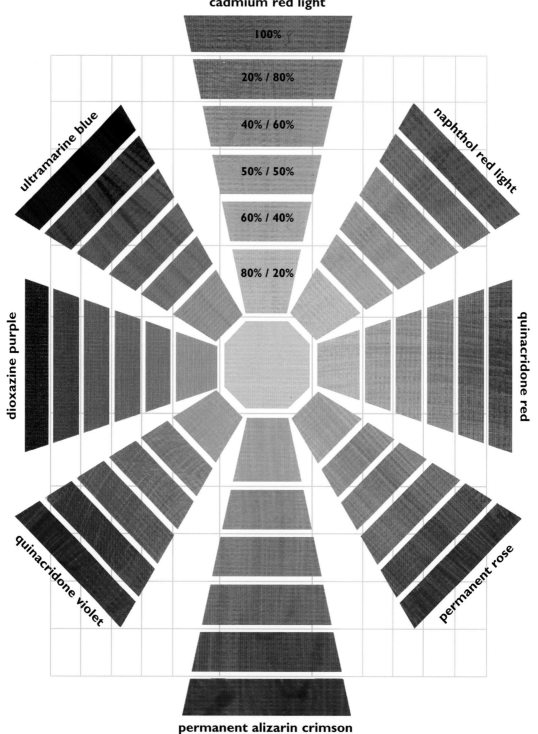

cadmium red light

100%

20% / 80%

40% / 60%

50% / 50%

60% / 40%

80% / 20%

ultramarine blue

naphthol red light

dioxazine purple

quinacridone red

quinacridone violet

permanent rose

permanent alizarin crimson

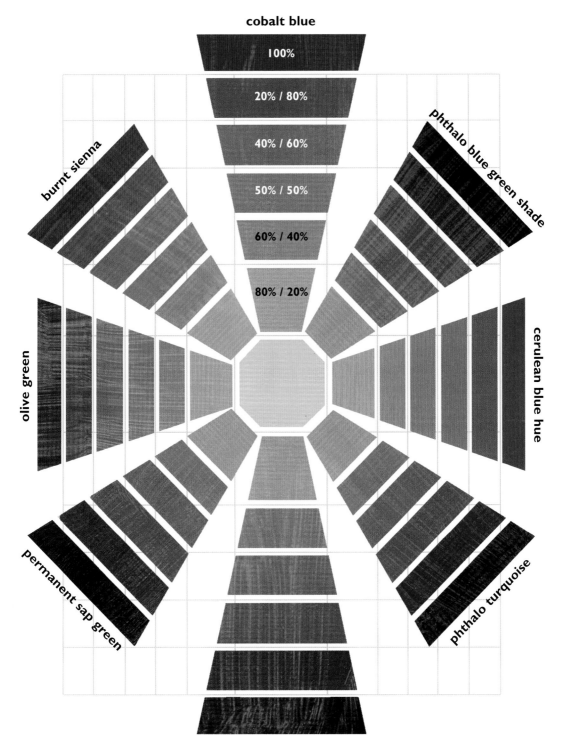

cobalt blue

100%

20% / 80%

40% / 60%

50% / 50%

60% / 40%

80% / 20%

phthalo blue green shade

burnt sienna

cerulean blue hue

olive green

permanent sap green

phthalo turquoise

phthalo green blue shade

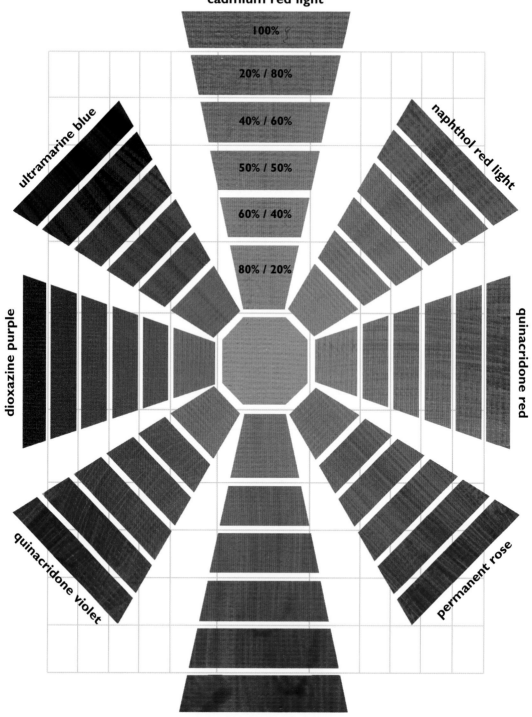

cadmium red light

100%

20% / 80%

40% / 60%

50% / 50%

60% / 40%

80% / 20%

ultramarine blue

naphthol red light

dioxazine purple

quinacridone red

quinacridone violet

permanent rose

permanent alizarin crimson

cobalt blue

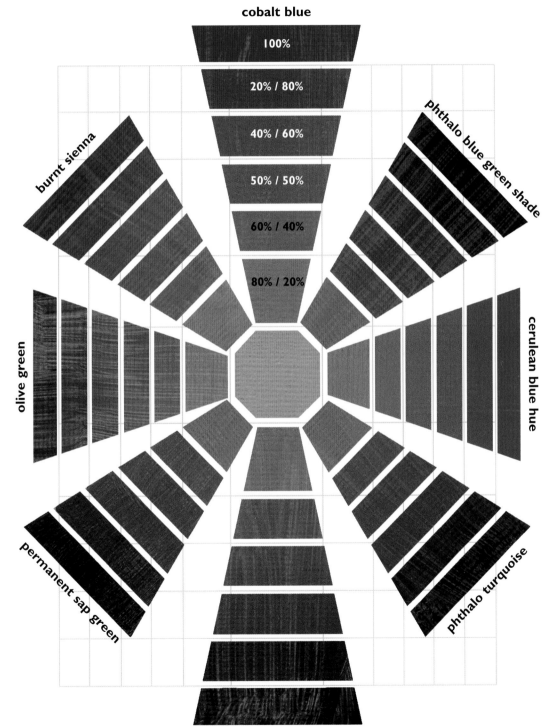

100%

20% / 80%

40% / 60%

50% / 50%

60% / 40%

80% / 20%

phthalo blue green shade

burnt sienna

cerulean blue hue

olive green

permanent sap green

phthalo turquoise

phthalo green blue shade

cadmium red light

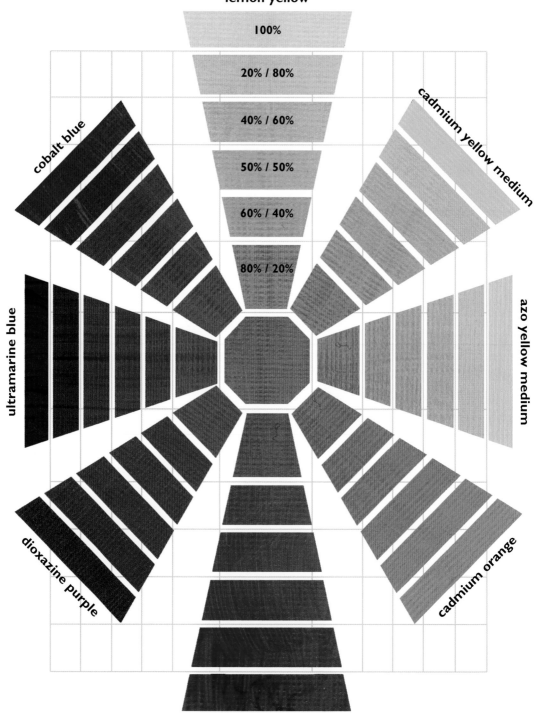

lemon yellow

100%

20% / 80%

40% / 60%

50% / 50%

60% / 40%

80% / 20%

cobalt blue

cadmium yellow medium

ultramarine blue

azo yellow medium

dioxazine purple

cadmium orange

quinacridone violet

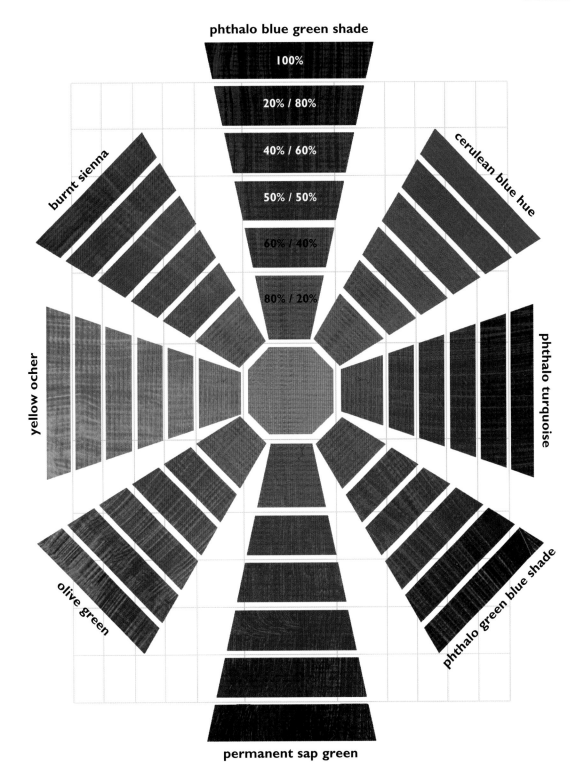

phthalo blue green shade

100%

20% / 80%

40% / 60%

50% / 50%

60% / 40%

80% / 20%

burnt sienna

cerulean blue hue

yellow ocher

phthalo turquoise

olive green

phthalo green blue shade

permanent sap green

naphthol red light

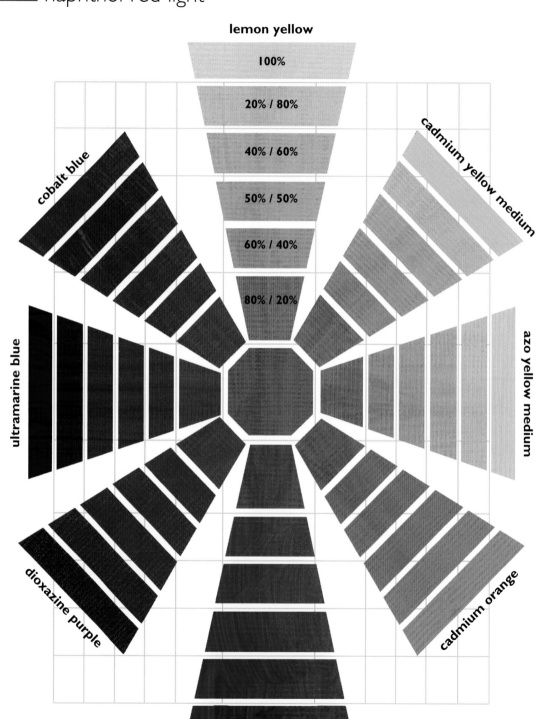

lemon yellow

100%

20% / 80%

40% / 60%

50% / 50%

60% / 40%

80% / 20%

cobalt blue

cadmium yellow medium

ultramarine blue

azo yellow medium

dioxazine purple

cadmium orange

quinacridone violet

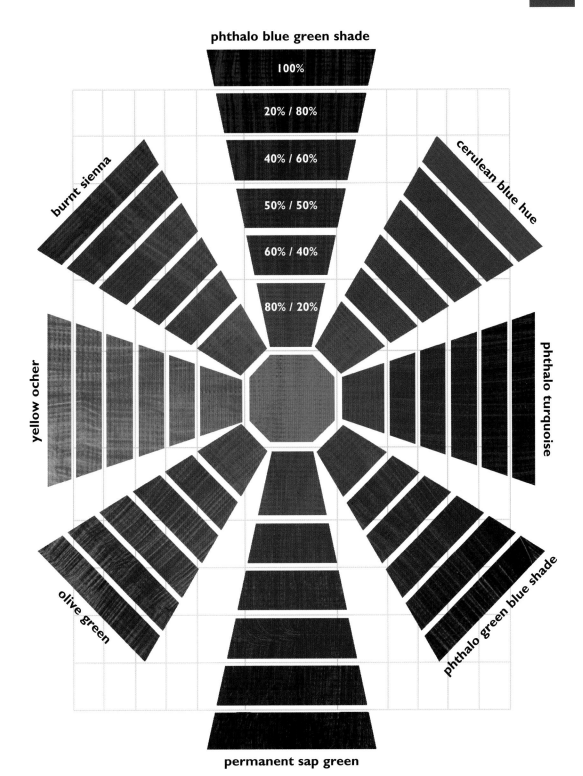

phthalo blue green shade

100%

20% / 80%

40% / 60%

50% / 50%

60% / 40%

80% / 20%

burnt sienna

cerulean blue hue

yellow ocher

phthalo turquoise

olive green

phthalo green blue shade

permanent sap green

quinacridone red

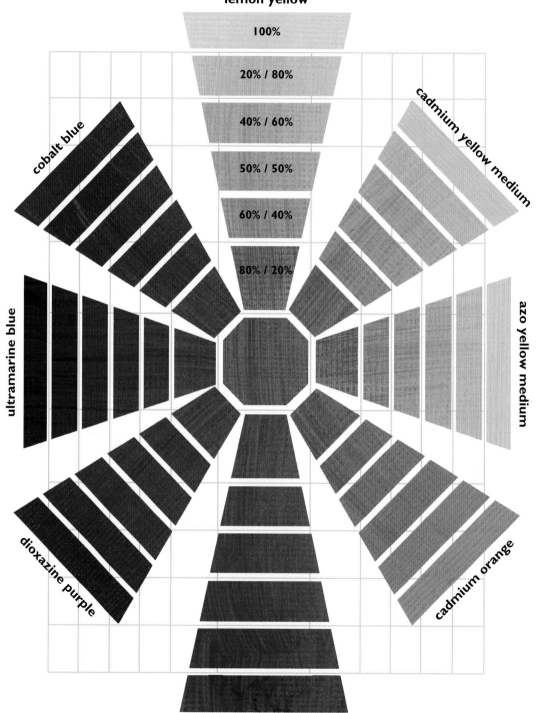

lemon yellow

100%

20% / 80%

40% / 60%

50% / 50%

60% / 40%

80% / 20%

cobalt blue

cadmium yellow medium

ultramarine blue

azo yellow medium

dioxazine purple

cadmium orange

quinacridone violet

phthalo blue green shade

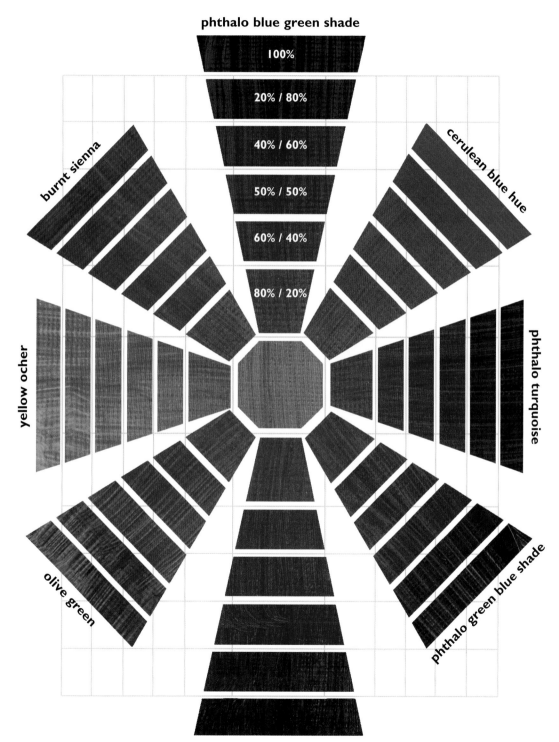

100%

20% / 80%

40% / 60%

50% / 50%

60% / 40%

80% / 20%

burnt sienna

cerulean blue hue

yellow ocher

phthalo turquoise

olive green

phthalo green blue shade

permanent sap green

permanent rose

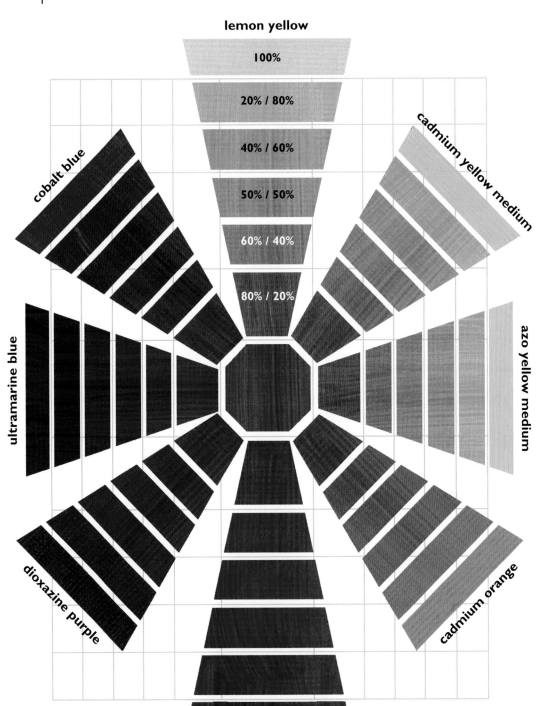

lemon yellow

100%

20% / 80%

40% / 60%

50% / 50%

60% / 40%

80% / 20%

cobalt blue

cadmium yellow medium

ultramarine blue

azo yellow medium

dioxazine purple

cadmium orange

quinacridone violet

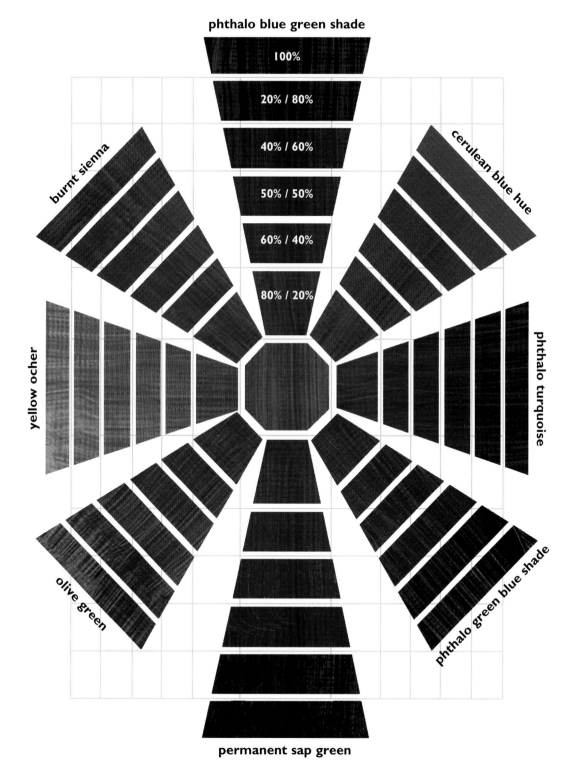

phthalo blue green shade

100%

20% / 80%

40% / 60%

50% / 50%

60% / 40%

80% / 20%

burnt sienna

cerulean blue hue

yellow ocher

phthalo turquoise

olive green

phthalo green blue shade

permanent sap green

permanent alizarin crimson

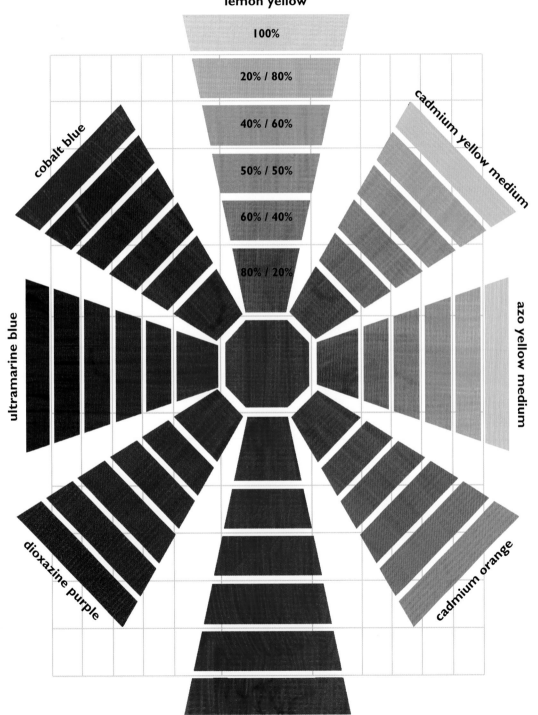

lemon yellow

100%

20% / 80%

40% / 60%

50% / 50%

60% / 40%

80% / 20%

cobalt blue

cadmium yellow medium

ultramarine blue

azo yellow medium

dioxazine purple

cadmium orange

quinacridone violet

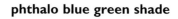

phthalo blue green shade

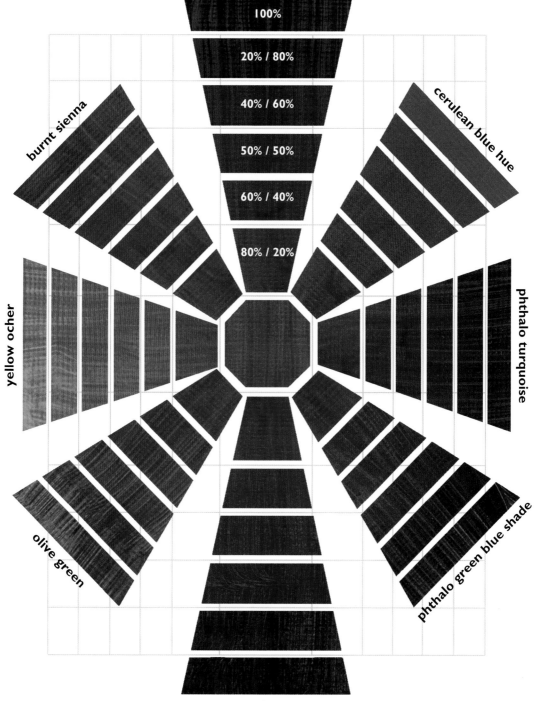

100%

20% / 80%

40% / 60%

50% / 50%

60% / 40%

80% / 20%

burnt sienna

cerulean blue hue

yellow ocher

phthalo turquoise

olive green

phthalo green blue shade

permanent sap green

quinacridone violet

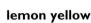

lemon yellow

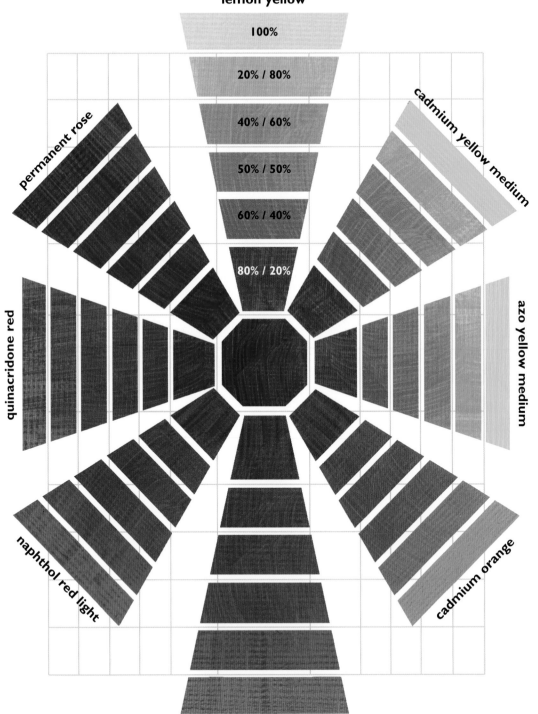

100%

20% / 80%

40% / 60%

50% / 50%

60% / 40%

80% / 20%

cadmium yellow medium

permanent rose

azo yellow medium

quinacridone red

naphthol red light

cadmium orange

cadmium red light

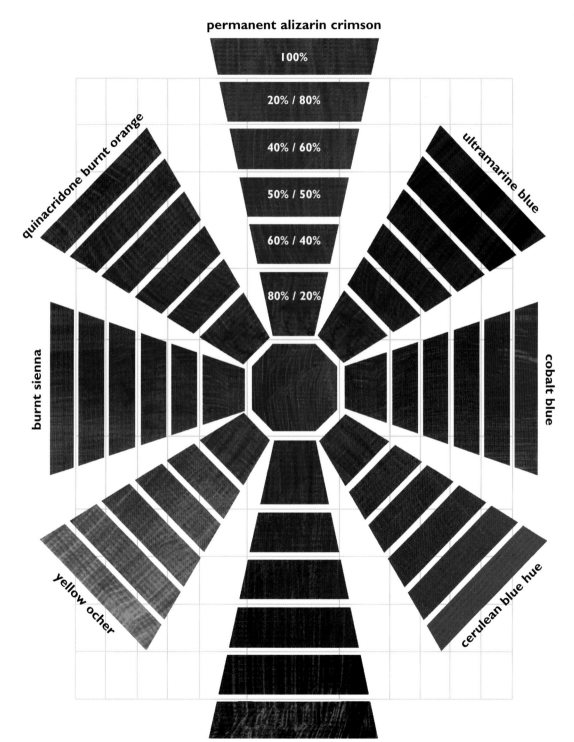

permanent alizarin crimson

100%

20% / 80%

40% / 60%

50% / 50%

60% / 40%

80% / 20%

quinacridone burnt orange

ultramarine blue

burnt sienna

cobalt blue

yellow ocher

cerulean blue hue

phthalo green blue shade

dioxazine purple

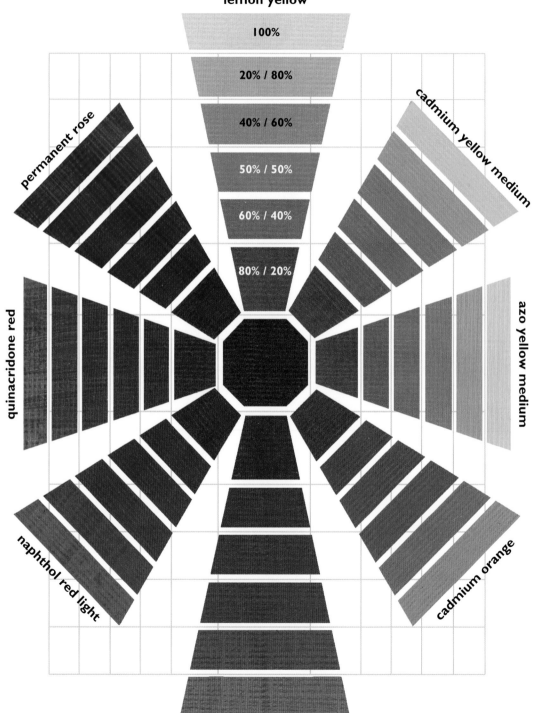

lemon yellow

100%

20% / 80%

40% / 60%

50% / 50%

60% / 40%

80% / 20%

permanent rose

cadmium yellow medium

quinacridone red

azo yellow medium

naphthol red light

cadmium orange

cadmium red light

permanent alizarin crimson

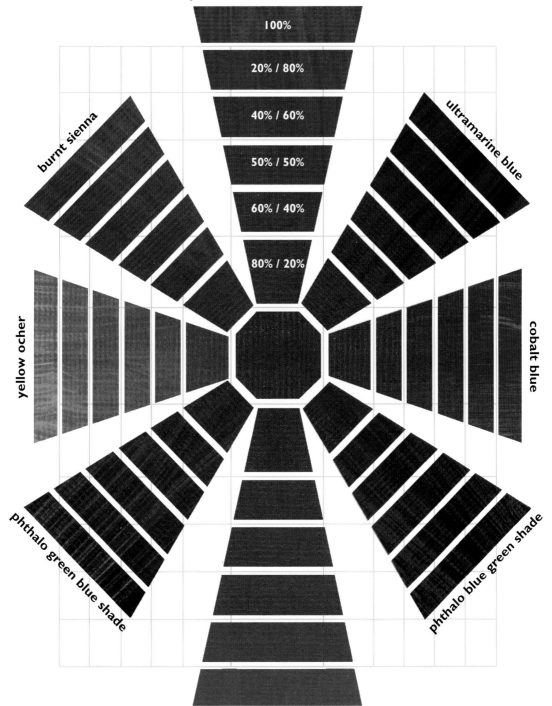

100%

20% / 80%

40% / 60%

50% / 50%

60% / 40%

80% / 20%

burnt sienna

ultramarine blue

yellow ocher

cobalt blue

phthalo green blue shade

phthalo blue green shade

cerulean blue hue

ultramarine blue

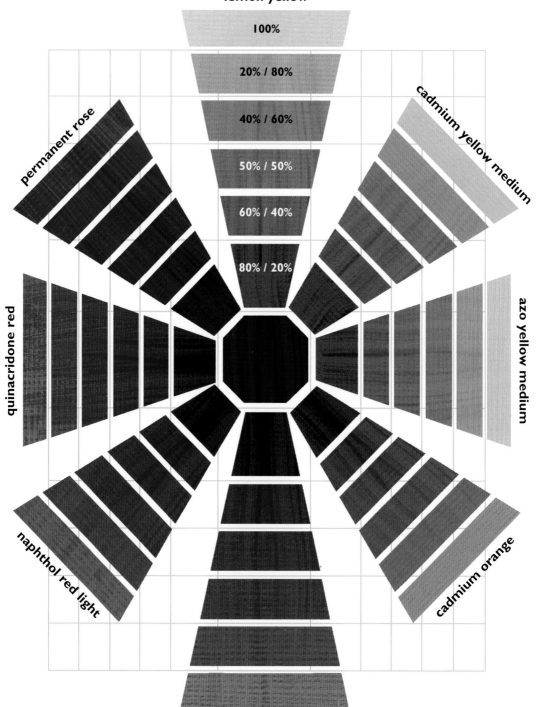

lemon yellow

100%

20% / 80%

40% / 60%

50% / 50%

60% / 40%

80% / 20%

cadmium yellow medium

azo yellow medium

cadmium orange

cadmium red light

naphthol red light

quinacridone red

permanent rose

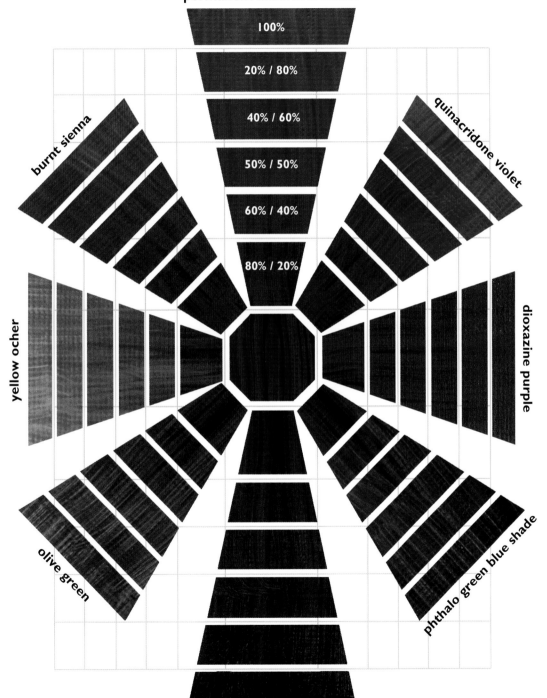

permanent alizarin crimson

100%

20% / 80%

40% / 60%

50% / 50%

60% / 40%

80% / 20%

burnt sienna

quinacridone violet

yellow ocher

dioxazine purple

olive green

phthalo green blue shade

permanent sap green

cobalt blue

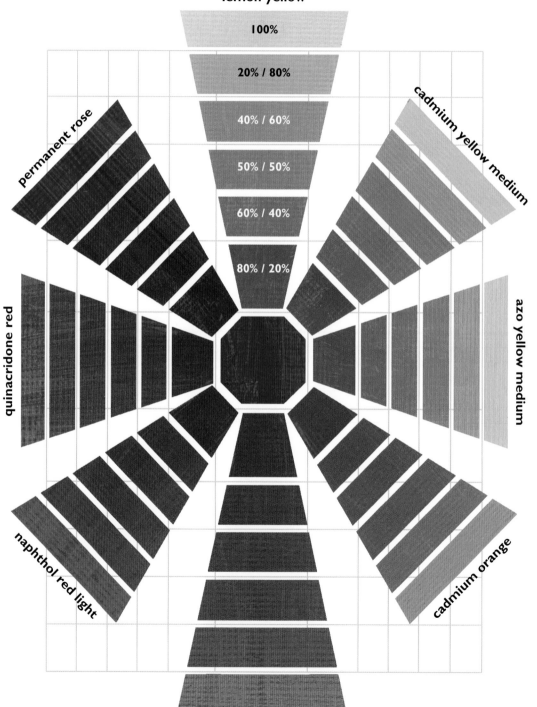

lemon yellow

100%

20% / 80%

40% / 60%

50% / 50%

60% / 40%

80% / 20%

permanent rose

cadmium yellow medium

quinacridone red

azo yellow medium

naphthol red light

cadmium orange

cadmium red light

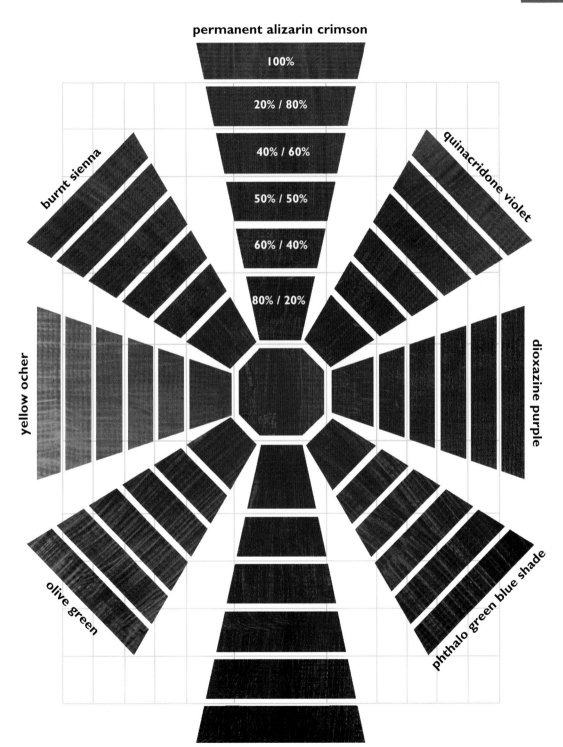

permanent alizarin crimson

100%

20% / 80%

40% / 60%

50% / 50%

60% / 40%

80% / 20%

burnt sienna

quinacridone violet

yellow ocher

dioxazine purple

olive green

phthalo green blue shade

permanent sap green

phthalo blue green shade

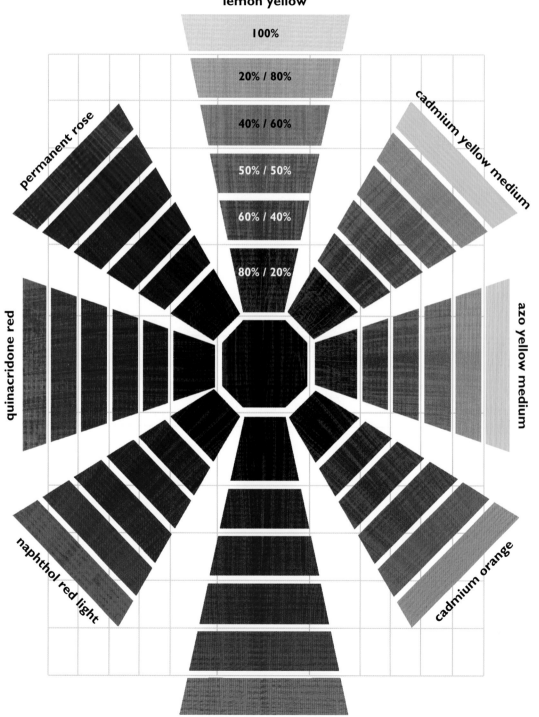

lemon yellow

100%

20% / 80%

40% / 60%

50% / 50%

60% / 40%

80% / 20%

permanent rose

cadmium yellow medium

quinacridone red

azo yellow medium

naphthol red light

cadmium orange

cadmium red light

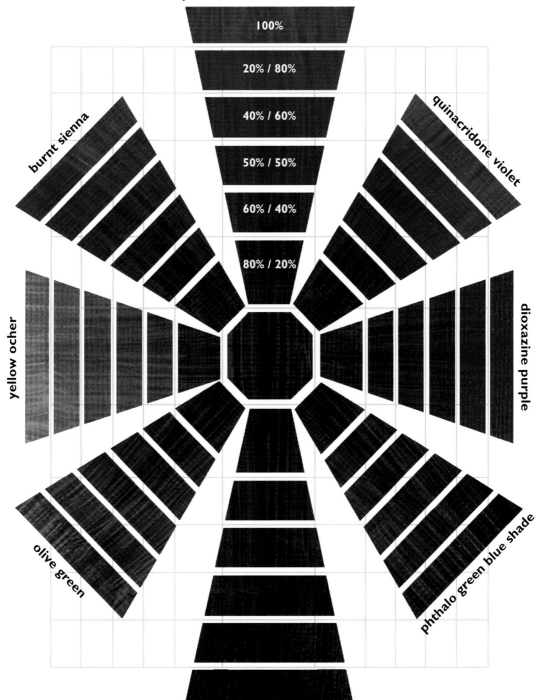

permanent alizarin crimson

100%

20% / 80%

40% / 60%

50% / 50%

60% / 40%

80% / 20%

burnt sienna

quinacridone violet

yellow ocher

dioxazine purple

olive green

phthalo green blue shade

permanent sap green

cerulean blue hue

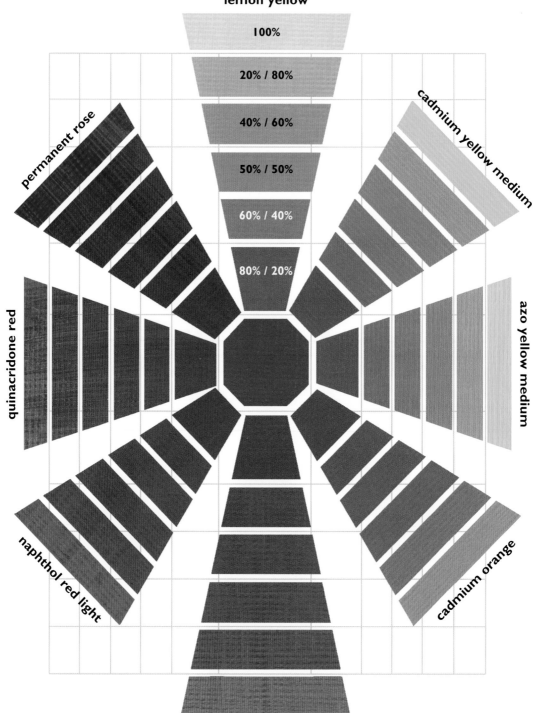

lemon yellow

100%

20% / 80%

40% / 60%

50% / 50%

60% / 40%

80% / 20%

permanent rose

cadmium yellow medium

quinacridone red

azo yellow medium

naphthol red light

cadmium orange

cadmium red light

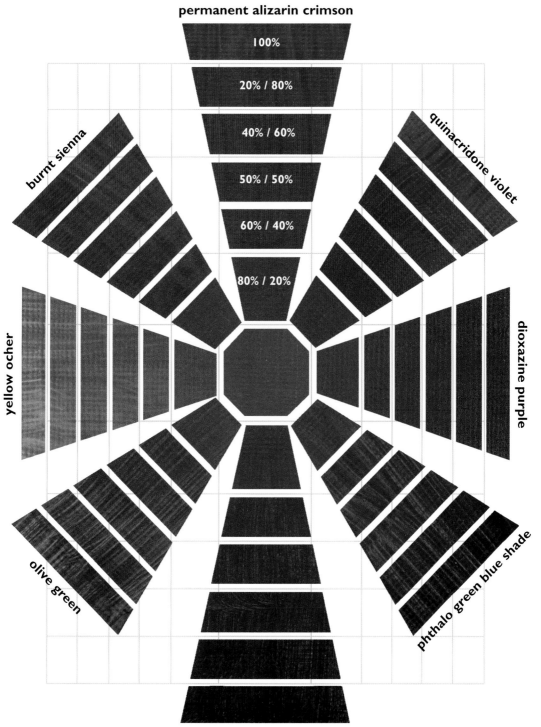

permanent alizarin crimson

100%

20% / 80%

40% / 60%

50% / 50%

60% / 40%

80% / 20%

burnt sienna

quinacridone violet

yellow ocher

dioxazine purple

olive green

phthalo green blue shade

permanent sap green

phthalo turquoise

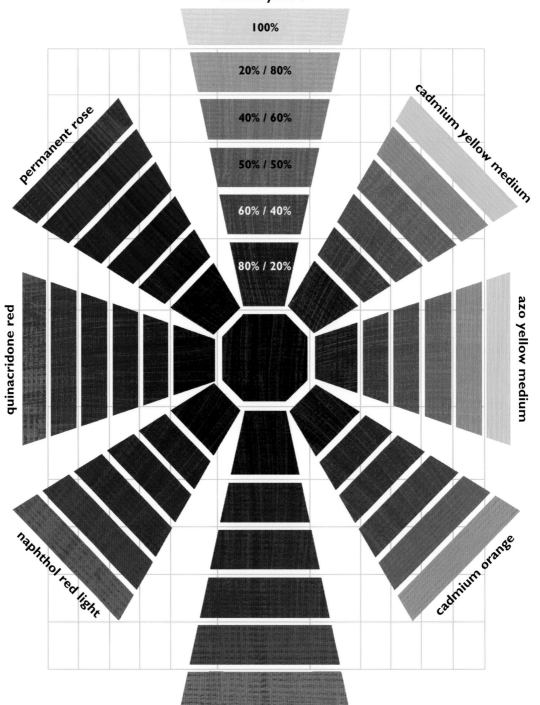

lemon yellow

100%

20% / 80%

40% / 60%

50% / 50%

60% / 40%

80% / 20%

cadmium yellow medium

permanent rose

azo yellow medium

quinacridone red

naphthol red light

cadmium orange

cadmium red light

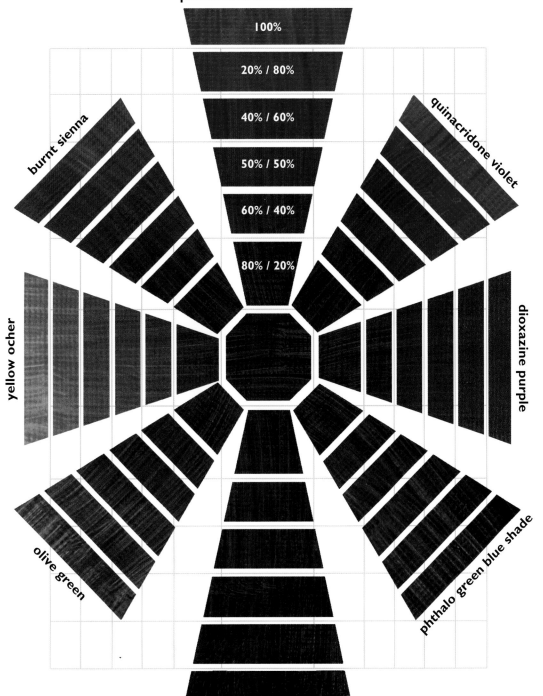

permanent alizarin crimson

100%

20% / 80%

40% / 60%

50% / 50%

60% / 40%

80% / 20%

burnt sienna

quinacridone violet

yellow ocher

dioxazine purple

olive green

phthalo green blue shade

permanent sap green

phthalo green blue shade

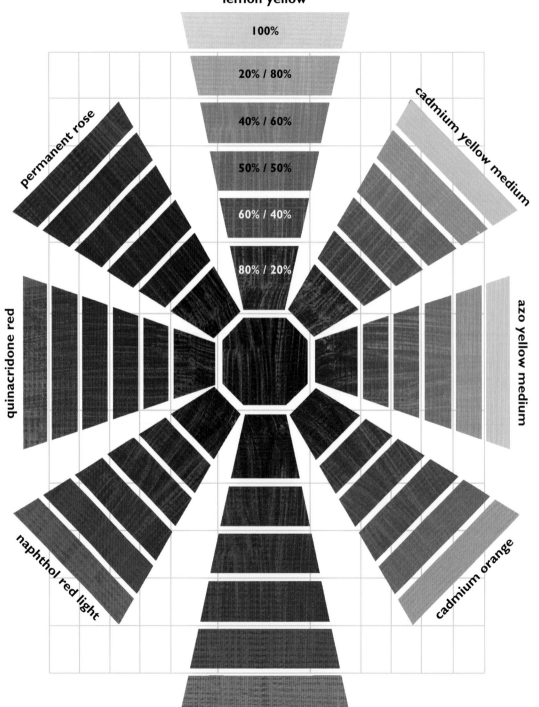

lemon yellow

100%

20% / 80%

40% / 60%

50% / 50%

60% / 40%

80% / 20%

cadmium yellow medium

permanent rose

quinacridone red

naphthol red light

azo yellow medium

cadmium orange

cadmium red light

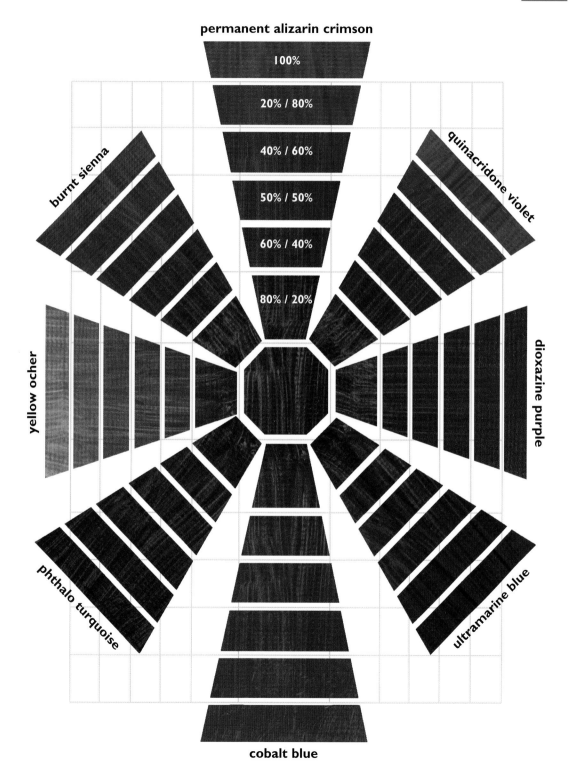

permanent alizarin crimson

100%

20% / 80%

40% / 60%

50% / 50%

60% / 40%

80% / 20%

burnt sienna

quinacridone violet

yellow ocher

dioxazine purple

phthalo turquoise

ultramarine blue

cobalt blue

permanent sap green

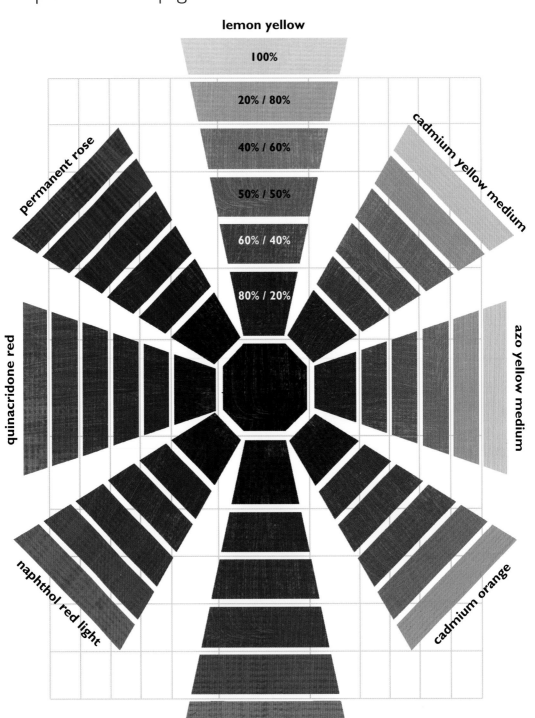

lemon yellow

100%

20% / 80%

40% / 60%

50% / 50%

60% / 40%

80% / 20%

cadmium yellow medium

permanent rose

azo yellow medium

quinacridone red

cadmium orange

naphthol red light

cadmium red light

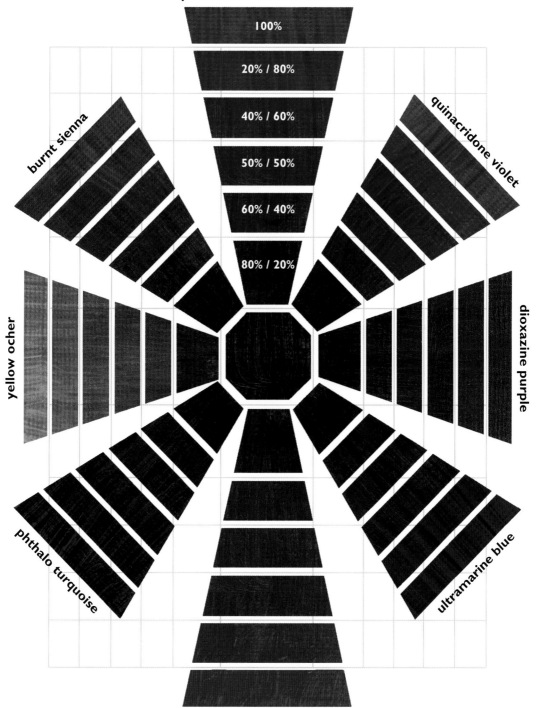

permanent alizarin crimson

100%

20% / 80%

40% / 60%

50% / 50%

60% / 40%

80% / 20%

burnt sienna

quinacridone violet

yellow ocher

dioxazine purple

phthalo turquoise

ultramarine blue

cobalt blue

olive green

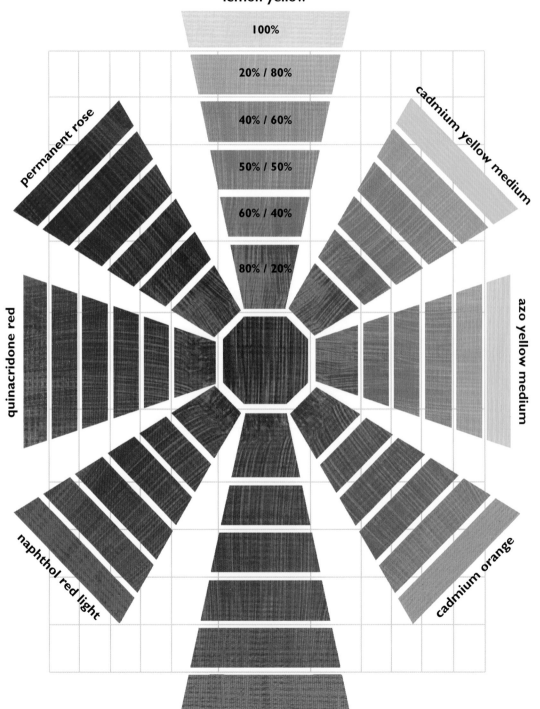

lemon yellow

100%

20% / 80%

40% / 60%

50% / 50%

60% / 40%

80% / 20%

permanent rose

cadmium yellow medium

quinacridone red

azo yellow medium

naphthol red light

cadmium orange

cadmium red light

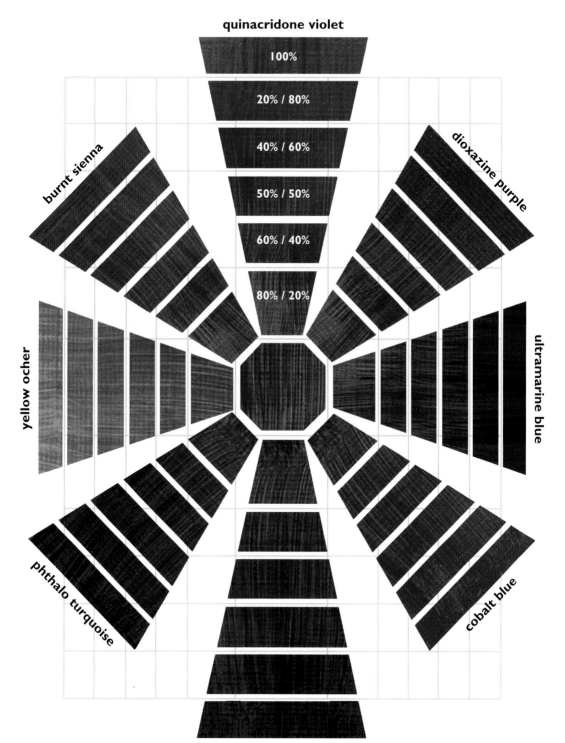

quinacridone violet

100%

20% / 80%

40% / 60%

50% / 50%

60% / 40%

80% / 20%

burnt sienna

dioxazine purple

yellow ocher

ultramarine blue

phthalo turquoise

cobalt blue

phthalo blue green shade

yellow ocher

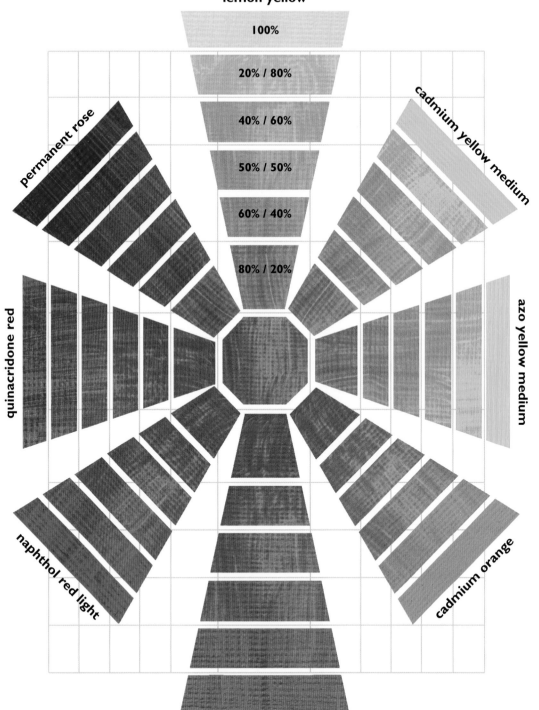

lemon yellow

100%

20% / 80%

40% / 60%

50% / 50%

60% / 40%

80% / 20%

cadmium yellow medium

permanent rose

quinacridone red

azo yellow medium

naphthol red light

cadmium orange

cadmium red light

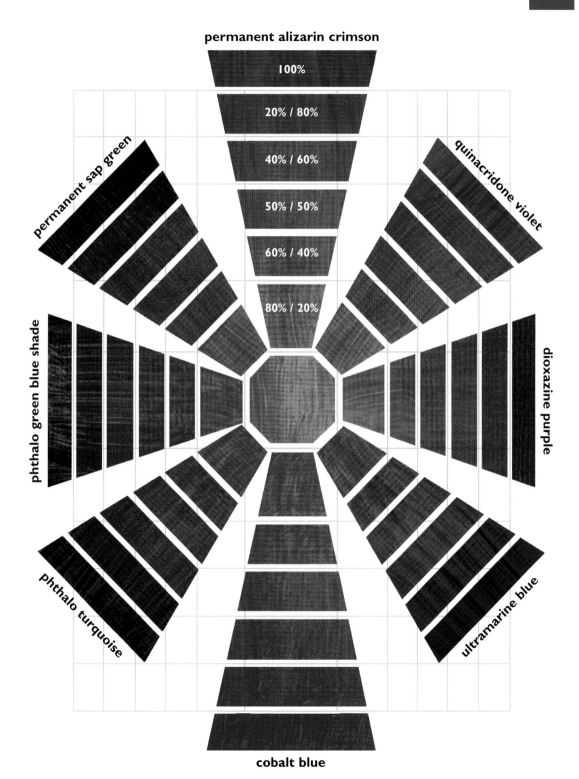

permanent alizarin crimson

100%

20% / 80%

40% / 60%

50% / 50%

60% / 40%

80% / 20%

permanent sap green

quinacridone violet

phthalo green blue shade

dioxazine purple

phthalo turquoise

ultramarine blue

cobalt blue

burnt sienna

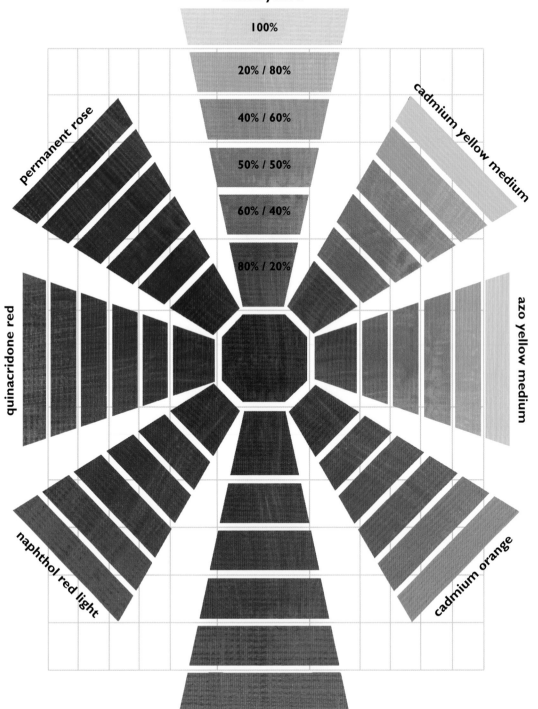

lemon yellow

100%

20% / 80%

40% / 60%

50% / 50%

60% / 40%

80% / 20%

permanent rose

cadmium yellow medium

quinacridone red

azo yellow medium

naphthol red light

cadmium orange

cadmium red light

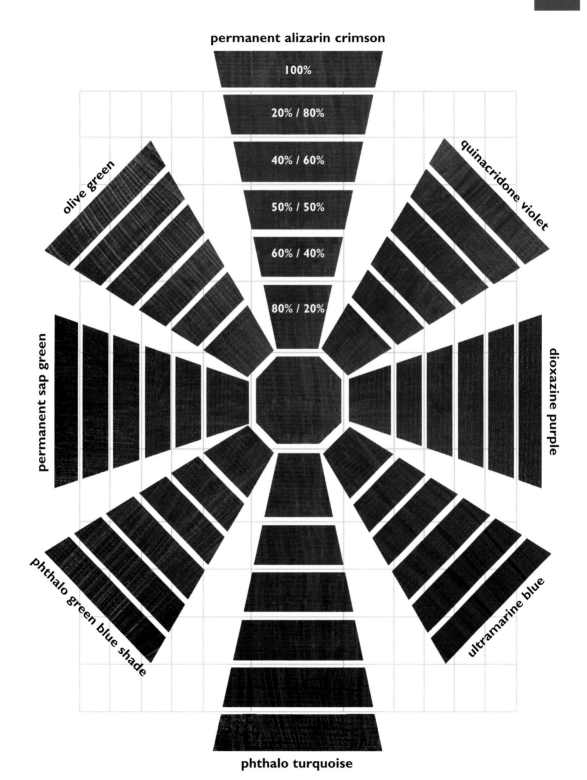

permanent alizarin crimson

100%

20% / 80%

40% / 60%

50% / 50%

60% / 40%

80% / 20%

olive green

quinacridone violet

permanent sap green

dioxazine purple

phthalo green blue shade

ultramarine blue

phthalo turquoise

red iron oxide

lemon yellow

100%

20% / 80%

40% / 60%

50% / 50%

60% / 40%

80% / 20%

cadmium yellow medium

permanent rose

quinacridone red

azo yellow medium

naphthol red light

cadmium orange

cadmium red light

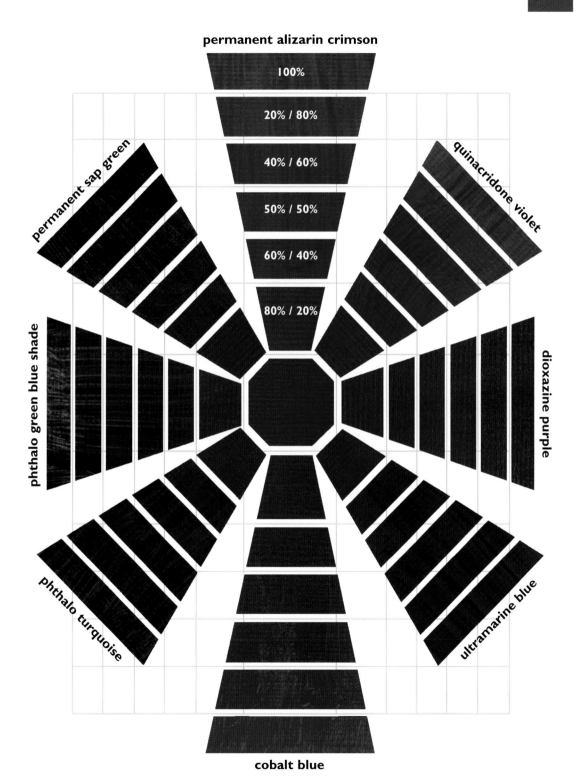

permanent alizarin crimson

100%

20% / 80%

40% / 60%

50% / 50%

60% / 40%

80% / 20%

permanent sap green

quinacridone violet

phthalo green blue shade

dioxazine purple

phthalo turquoise

ultramarine blue

cobalt blue

quinacridone burnt orange

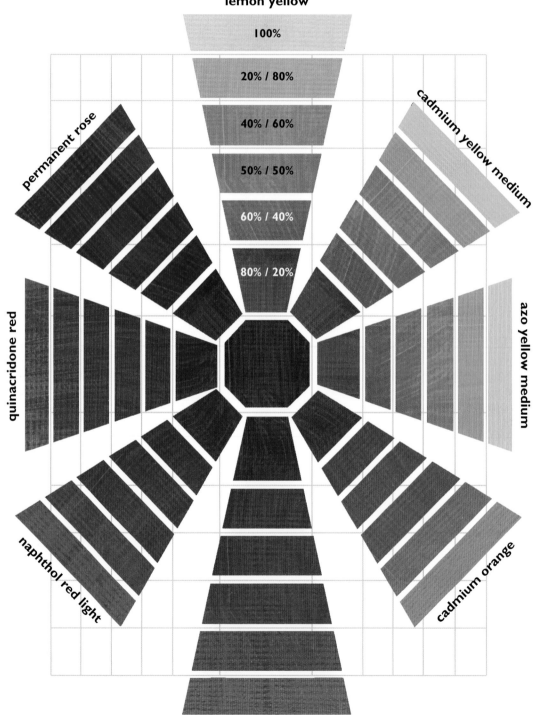

lemon yellow

100%

20% / 80%

40% / 60%

50% / 50%

60% / 40%

80% / 20%

cadmium yellow medium

permanent rose

azo yellow medium

quinacridone red

naphthol red light

cadmium orange

cadmium red light

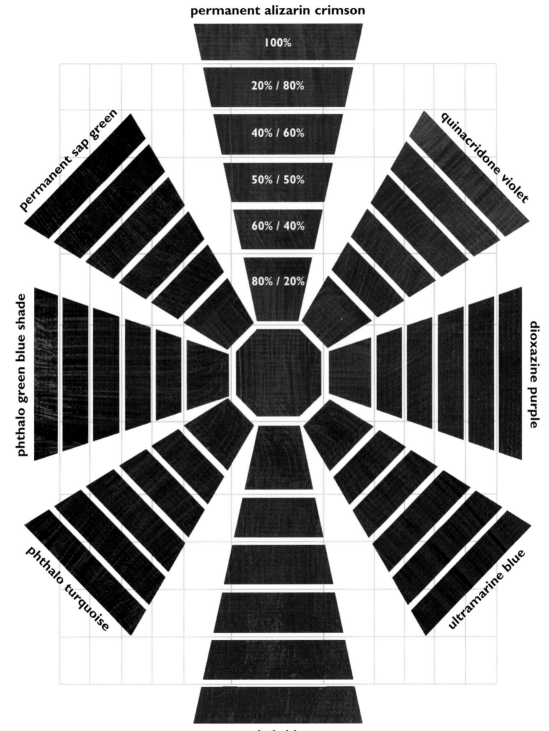

permanent alizarin crimson

100%

20% / 80%

40% / 60%

50% / 50%

60% / 40%

80% / 20%

permanent sap green

quinacridone violet

phthalo green blue shade

dioxazine purple

phthalo turquoise

ultramarine blue

cobalt blue

raw umber

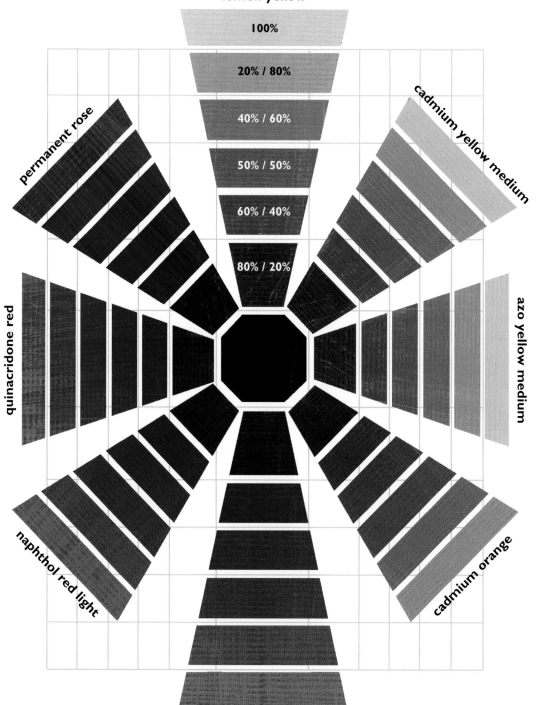

lemon yellow

100%

20% / 80%

40% / 60%

50% / 50%

60% / 40%

80% / 20%

cadmium yellow medium

permanent rose

azo yellow medium

quinacridone red

naphthol red light

cadmium orange

cadmium red light

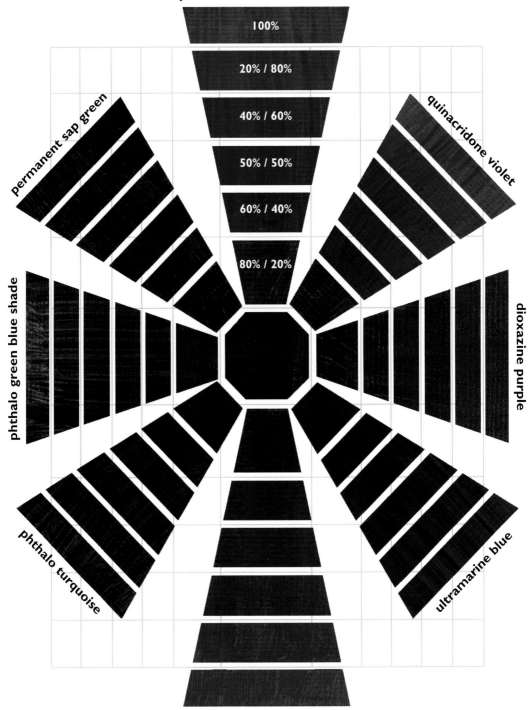

permanent alizarin crimson

100%

20% / 80%

40% / 60%

50% / 50%

60% / 40%

80% / 20%

permanent sap green

quinacridone violet

phthalo green blue shade

dioxazine purple

phthalo turquoise

ultramarine blue

cobalt blue

Payne's gray

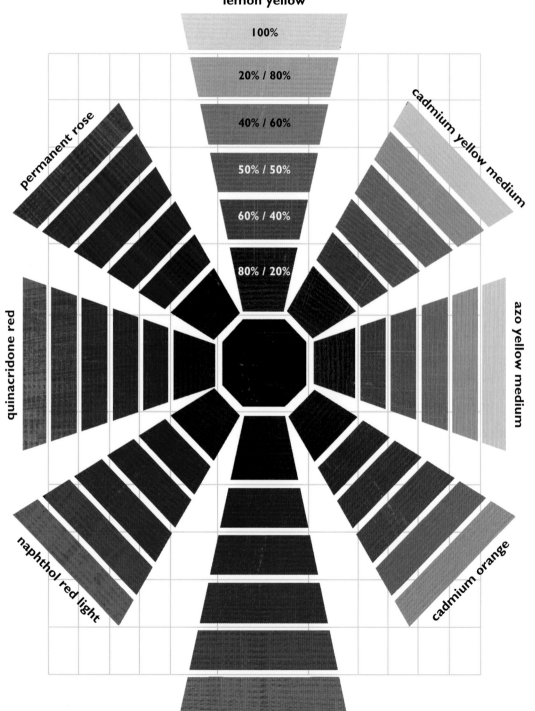

lemon yellow

100%

20% / 80%

40% / 60%

50% / 50%

60% / 40%

80% / 20%

cadmium yellow medium

azo yellow medium

cadmium orange

cadmium red light

naphthol red light

quinacridone red

permanent rose

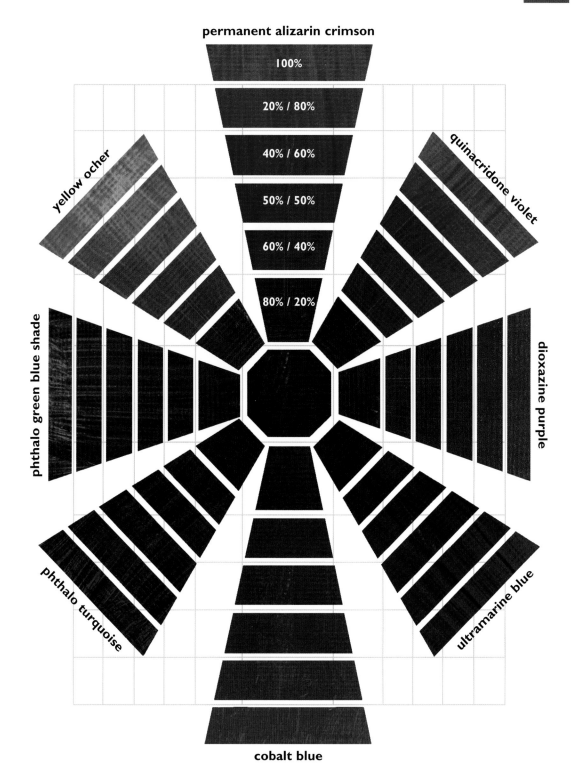

permanent alizarin crimson

100%

20% / 80%

40% / 60%

50% / 50%

60% / 40%

80% / 20%

yellow ocher

quinacridone violet

phthalo green blue shade

dioxazine purple

phthalo turquoise

ultramarine blue

cobalt blue

oil color mixes

The following pages feature 25 main oil colors that are the most popular with amateur and professional artists. The mixes demonstrate that artists need very few colors to create an enormous range of bright, vibrant colors in oil paint. Use these mixes as guides to help you achieve the exact shade you want, whatever your subject.

supports and brushes

To mix oil colors, you need a flat, smooth surface that will not absorb the oil. The traditional palette in wood or plastic, including a thumb hole, is necessary for portrait and outdoor work, but in the studio many artists use a piece of glass, plastic, or glazed ceramic appropriate to the size of their paintings. The ultimate in economy is to use a glossy magazine and tear off each page when it is full.

Squeeze out each color onto your palette as a long line of paint rather than as a large round blob. You will then be able to take color from the end of the line without staining the rest of the paint: Any paint left will be clean for further use. Place each color along the far edge of your palette so that you can see all the colors clearly. The order of the colors on the palette is a matter of personal choice, but do not change it too often, as this will slow down the work. One idea is to start with cool colors, the blues and violets, on the left, moving through the yellows to the ochers and earth colors with reds on the right. Place white and black on the extreme right.

A traditional paint box containing 12 or 24 tubes of color, together with palette, brushes, and thinning oils, ensures everything is at hand when you are ready to paint.

SUPPORTS FOR OIL PAINTING

Wood panels, canvas, card-backed canvas, hardboard, MDF (medium-density fiberboard), card, and paper (properly primed to prevent the paint from sinking) are all suitable grounds for oil painting.

The difficulty and expense of joining wood to make large panels and their tendency to crack led to the use of canvas and other textiles that were lighter in weight and allowed much larger pictures to be made and hung. Pictures in the 19th-century French salons were sometimes 33 feet (10 m) long. The woven texture of canvas allows every variation from smooth grain to extremely coarse to be used, and it gives the opportunity to elaborate yet more ways of painting with oils in the future.

BRUSHES

Hog-hair brushes are the most popular brushes for oil painting; they are the most effective when handling paint from tubes diluted, if at all, with a little turpentine. Paint dissolved with other liquids or resins requires softer fibers or hairs to enable you to obtain softer blending. Of these, sable is still the best, but by a narrower margin than in the past. The various synthetic fibers offer good quality at a fraction of the cost of sable.

When you begin to use the opaque method of painting by adding white to alter the tone of the colors, use a palette knife to do the mixing so that your clean brush is ready to pick up just the amount of paint needed.

Many painters who favor a broader approach use palette knives and other painting tools either to add dramatic touches or to paint the whole picture.

Choose several hog-hair brushes in different sizes and shapes for your oil painting. This allows you to create works of art, whatever your style. Palette knives are useful additions.

the oil color palette

These are the most popular oil colors with professional and amateur artists, available in art stores and via the Internet. Colors that are included in many preselected paint boxes are also chosen from this range.

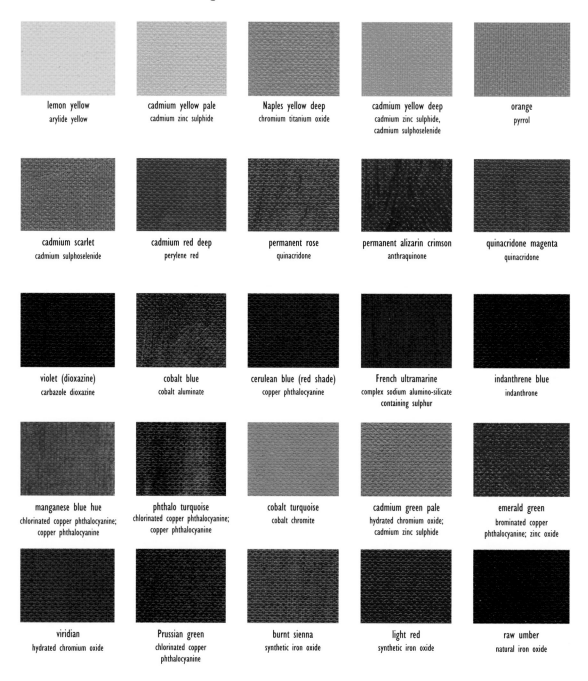

lemon yellow
arylide yellow

cadmium yellow pale
cadmium zinc sulphide

Naples yellow deep
chromium titanium oxide

cadmium yellow deep
cadmium zinc sulphide,
cadmium sulphoselenide

orange
pyrrol

cadmium scarlet
cadmium sulphoselenide

cadmium red deep
perylene red

permanent rose
quinacridone

permanent alizarin crimson
anthraquinone

quinacridone magenta
quinacridone

violet (dioxazine)
carbazole dioxazine

cobalt blue
cobalt aluminate

cerulean blue (red shade)
copper phthalocyanine

French ultramarine
complex sodium alumino-silicate
containing sulphur

indanthrene blue
indanthrone

manganese blue hue
chlorinated copper phthalocyanine;
copper phthalocyanine

phthalo turquoise
chlorinated copper phthalocyanine;
copper phthalocyanine

cobalt turquoise
cobalt chromite

cadmium green pale
hydrated chromium oxide;
cadmium zinc sulphide

emerald green
brominated copper
phthalocyanine; zinc oxide

viridian
hydrated chromium oxide

Prussian green
chlorinated copper
phthalocyanine

burnt sienna
synthetic iron oxide

light red
synthetic iron oxide

raw umber
natural iron oxide

SUGGESTED PALETTE

It is a good idea for beginners to start with a very restricted palette of six colors and use the charts relating to these six colors to develop their color skills and discover their preferences. They can then augment their palette as they gain experience. A good minimum palette for a beginner is shown here:

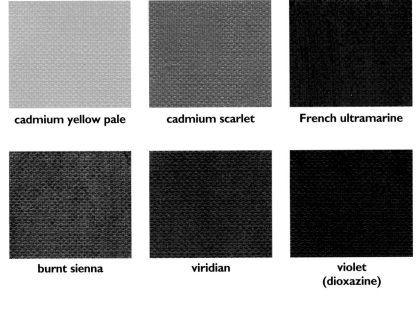

cadmium yellow pale **cadmium scarlet** **French ultramarine**

burnt sienna **viridian** **violet (dioxazine)**

One of the most popular supports for works in oil paints is canvas. Canvases are available pre-stretched in various sizes and different textures from smooth to extremely coarse grained.

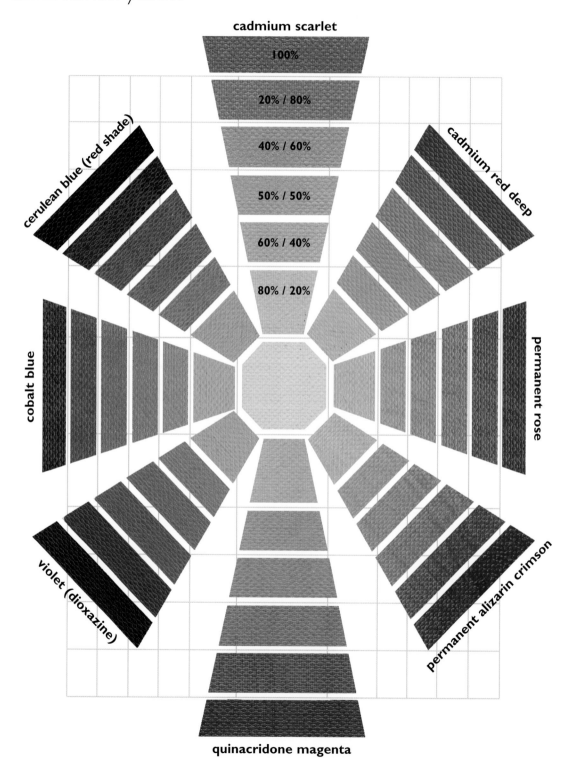

cadmium scarlet

100%

20% / 80%

40% / 60%

50% / 50%

60% / 40%

80% / 20%

cerulean blue (red shade)

cadmium red deep

cobalt blue

permanent rose

violet (dioxazine)

permanent alizarin crimson

quinacridone magenta

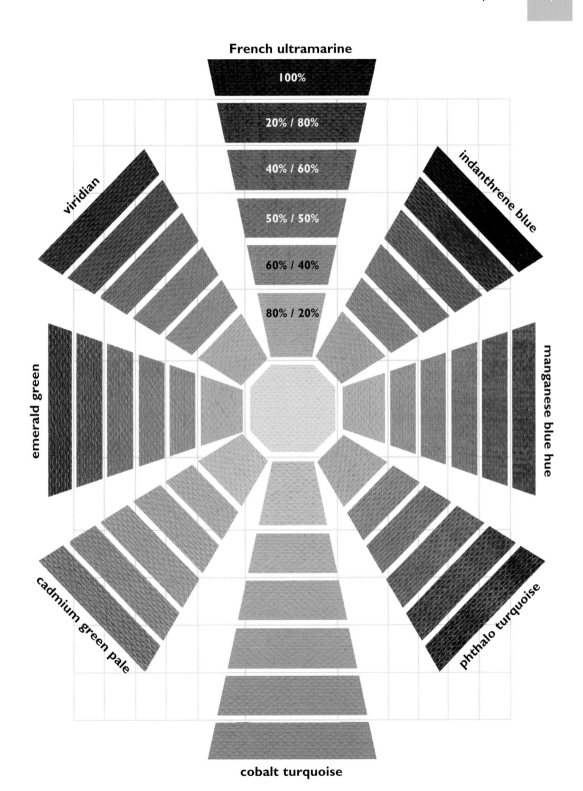

French ultramarine

100%

20% / 80%

40% / 60%

50% / 50%

60% / 40%

80% / 20%

viridian

indanthrene blue

emerald green

manganese blue hue

cadmium green pale

phthalo turquoise

cobalt turquoise

cadmium yellow pale

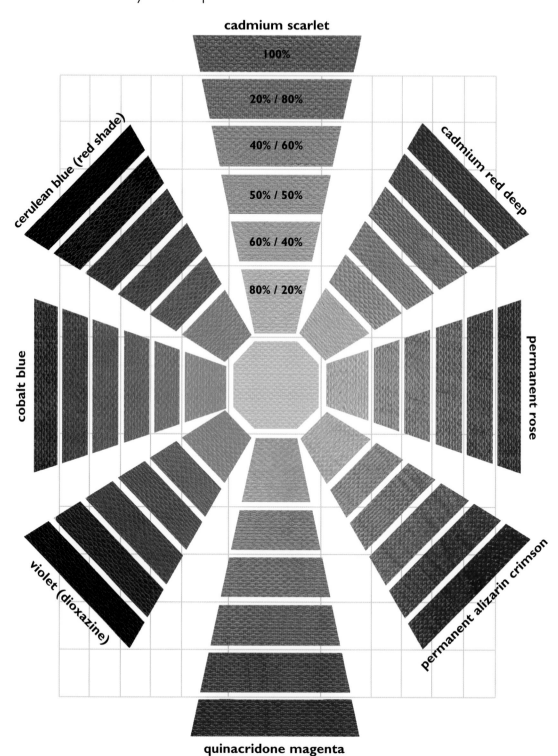

cadmium scarlet

100%

20% / 80%

40% / 60%

50% / 50%

60% / 40%

80% / 20%

cerulean blue (red shade)

cadmium red deep

cobalt blue

permanent rose

violet (dioxazine)

permanent alizarin crimson

quinacridone magenta

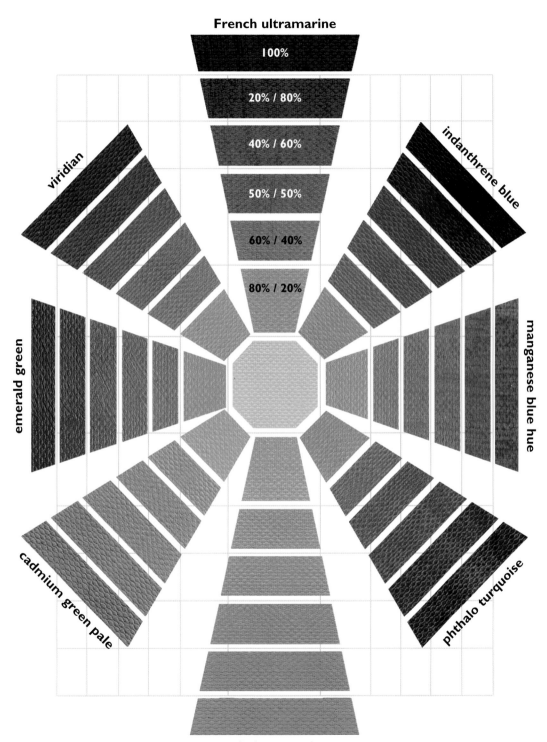

French ultramarine

100%

20% / 80%

40% / 60%

50% / 50%

60% / 40%

80% / 20%

viridian

indanthrene blue

emerald green

manganese blue hue

cadmium green pale

phthalo turquoise

cobalt turquoise

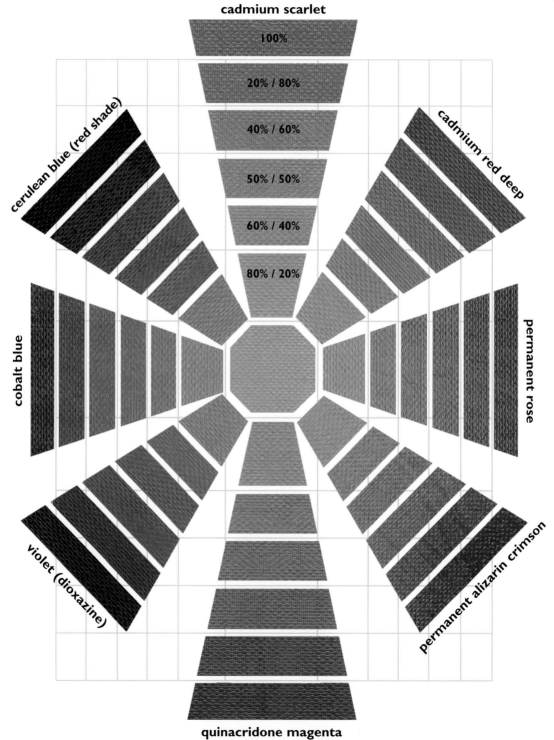

cadmium scarlet

100%

20% / 80%

40% / 60%

50% / 50%

60% / 40%

80% / 20%

cerulean blue (red shade)

cadmium red deep

cobalt blue

permanent rose

violet (dioxazine)

permanent alizarin crimson

quinacridone magenta

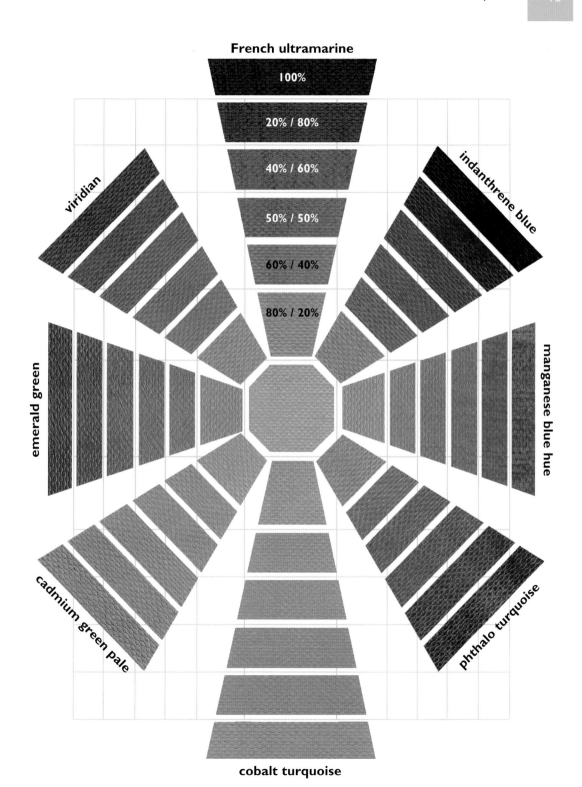

French ultramarine

100%

20% / 80%

40% / 60%

50% / 50%

60% / 40%

80% / 20%

viridian

indanthrene blue

emerald green

manganese blue hue

cadmium green pale

phthalo turquoise

cobalt turquoise

cadmium yellow deep

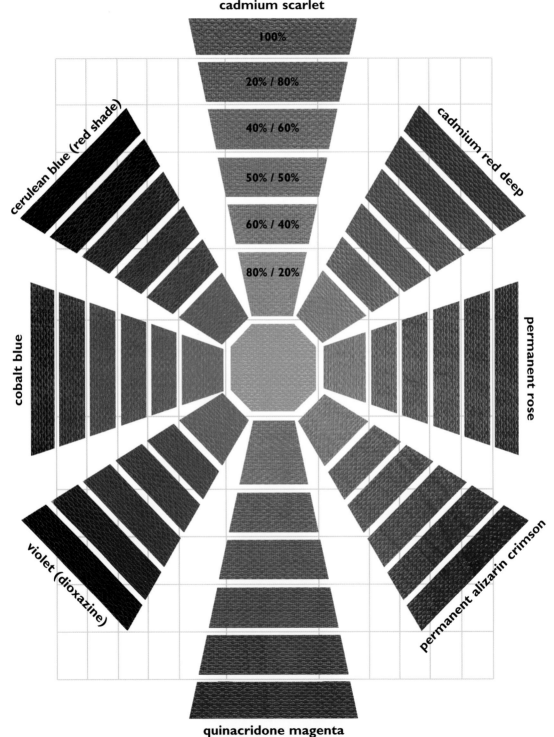

cadmium scarlet

100%

20% / 80%

40% / 60%

50% / 50%

60% / 40%

80% / 20%

cerulean blue (red shade)

cadmium red deep

cobalt blue

permanent rose

violet (dioxazine)

permanent alizarin crimson

quinacridone magenta

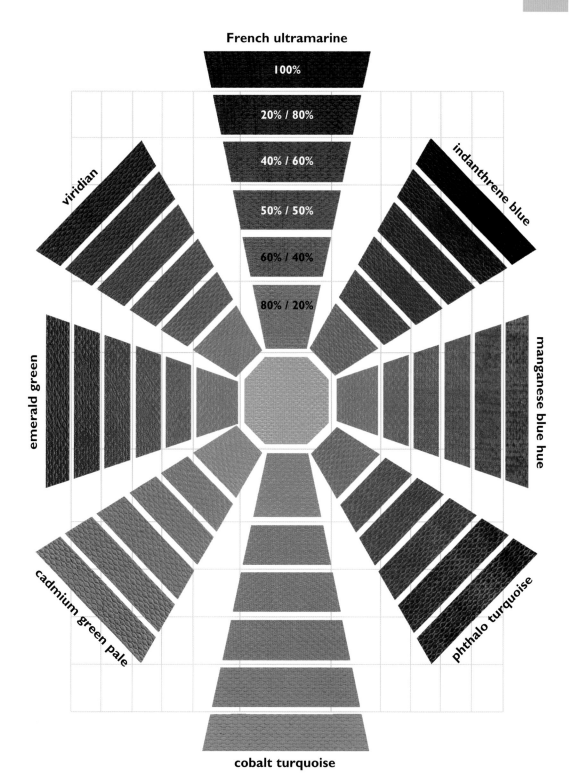

French ultramarine

100%

20% / 80%

40% / 60%

50% / 50%

60% / 40%

80% / 20%

viridian

indanthrene blue

emerald green

manganese blue hue

cadmium green pale

phthalo turquoise

cobalt turquoise

orange

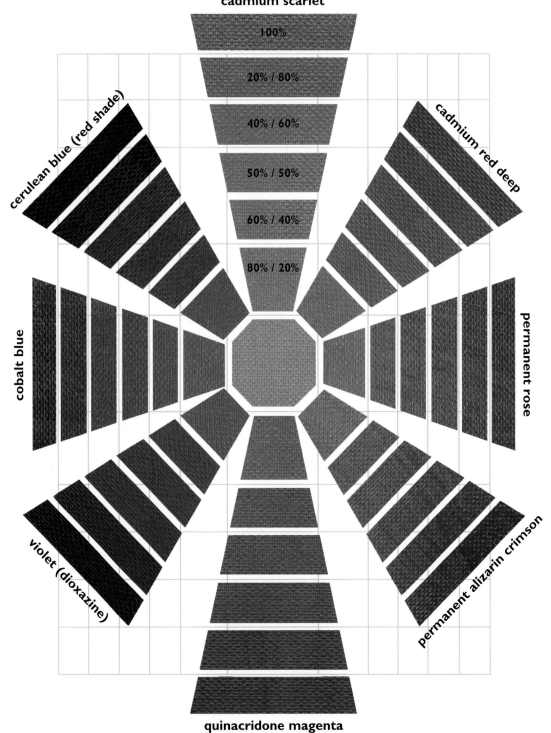

cadmium scarlet

100%

20% / 80%

40% / 60%

50% / 50%

60% / 40%

80% / 20%

cerulean blue (red shade)

cadmium red deep

cobalt blue

permanent rose

violet (dioxazine)

permanent alizarin crimson

quinacridone magenta

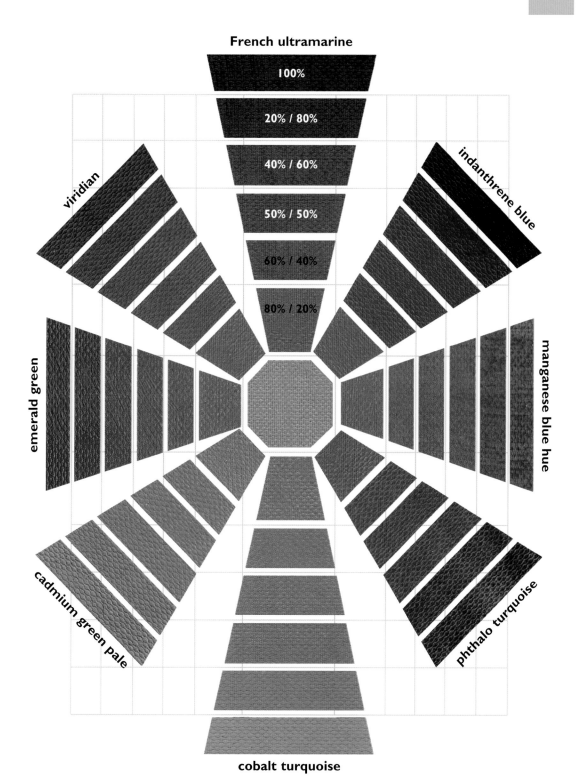

French ultramarine

100%

20% / 80%

40% / 60%

50% / 50%

60% / 40%

80% / 20%

viridian

indanthrene blue

emerald green

manganese blue hue

cadmium green pale

phthalo turquoise

cobalt turquoise

cadmium scarlet

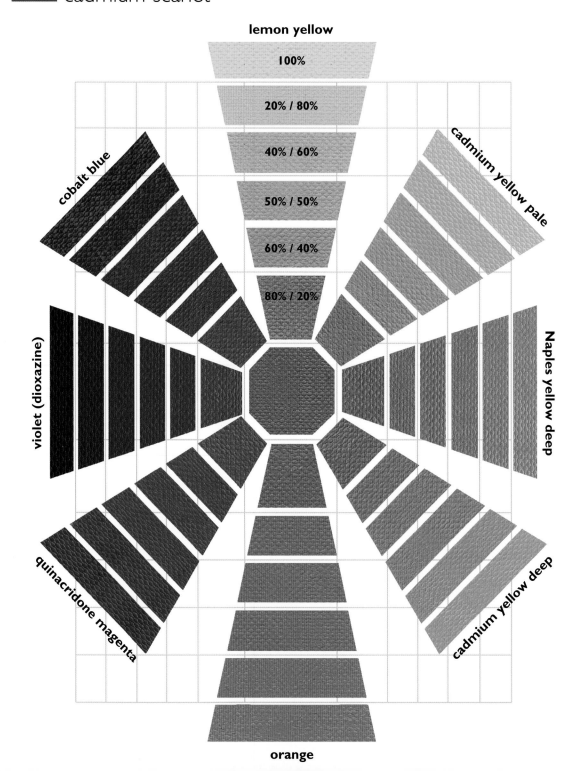

lemon yellow

100%

20% / 80%

40% / 60%

50% / 50%

60% / 40%

80% / 20%

cobalt blue

cadmium yellow pale

violet (dioxazine)

Naples yellow deep

quinacridone magenta

cadmium yellow deep

orange

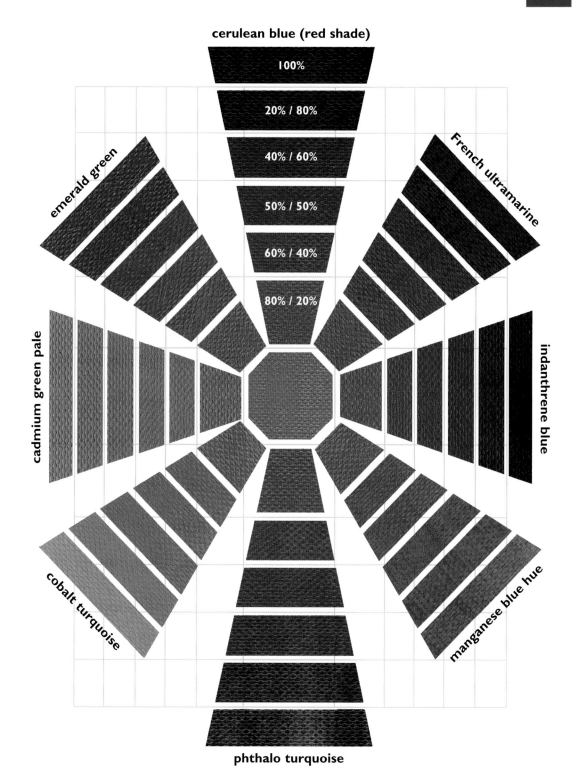

cerulean blue (red shade)

100%

20% / 80%

40% / 60%

50% / 50%

60% / 40%

80% / 20%

emerald green

French ultramarine

cadmium green pale

indanthrene blue

cobalt turquoise

manganese blue hue

phthalo turquoise

cadmium red deep

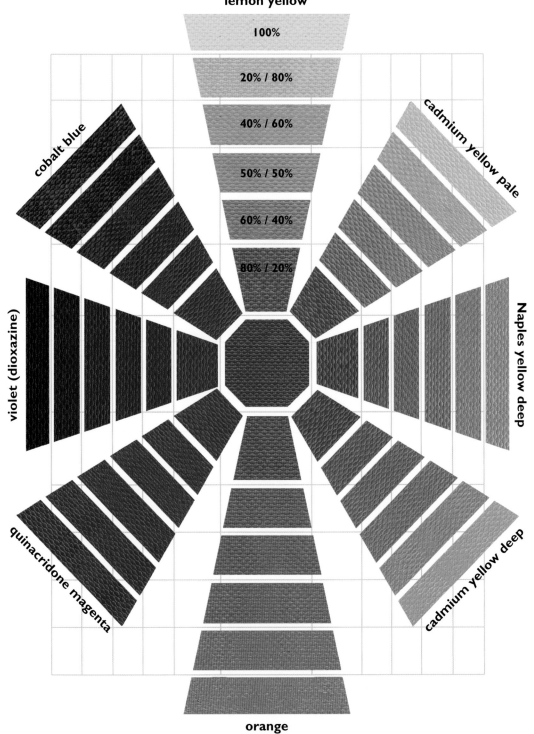

lemon yellow

100%

20% / 80%

40% / 60%

50% / 50%

60% / 40%

80% / 20%

cobalt blue

cadmium yellow pale

Naples yellow deep

violet (dioxazine)

cadmium yellow deep

quinacridone magenta

orange

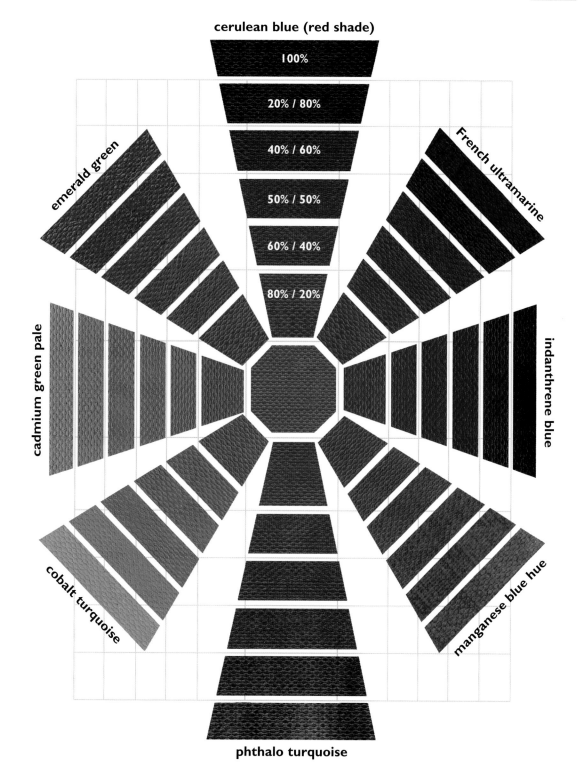

cerulean blue (red shade)

100%

20% / 80%

40% / 60%

50% / 50%

60% / 40%

80% / 20%

emerald green

French ultramarine

cadmium green pale

indanthrene blue

cobalt turquoise

manganese blue hue

phthalo turquoise

permanent rose

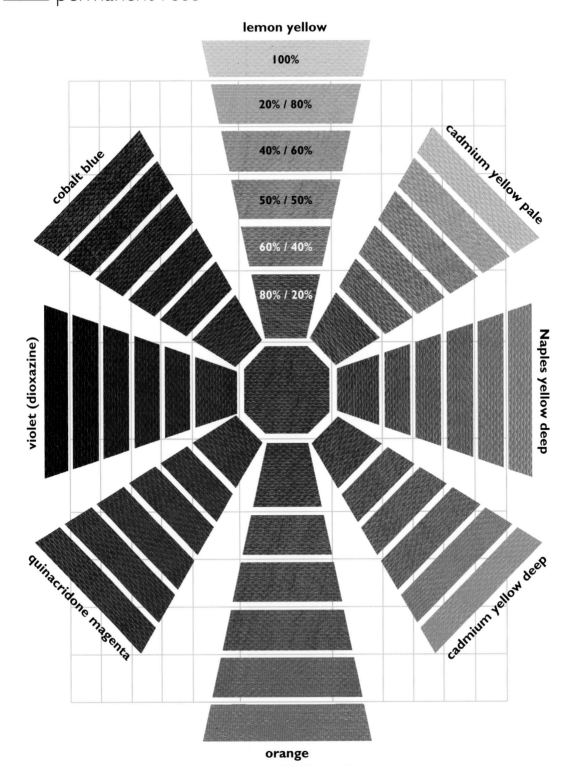

lemon yellow

100%

20% / 80%

40% / 60%

50% / 50%

60% / 40%

80% / 20%

cobalt blue

cadmium yellow pale

violet (dioxazine)

Naples yellow deep

quinacridone magenta

cadmium yellow deep

orange

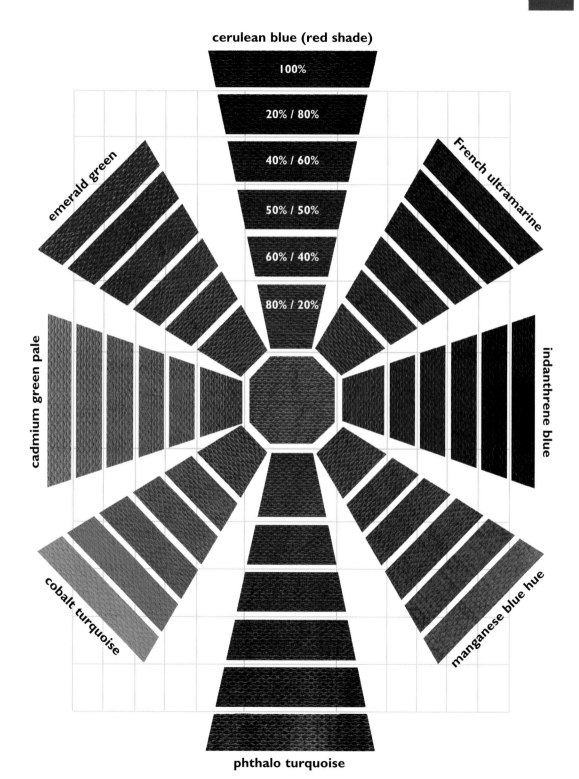

cerulean blue (red shade)

100%

20% / 80%

40% / 60%

50% / 50%

60% / 40%

80% / 20%

emerald green

French ultramarine

cadmium green pale

indanthrene blue

cobalt turquoise

manganese blue hue

phthalo turquoise

permanent alizarin crimson

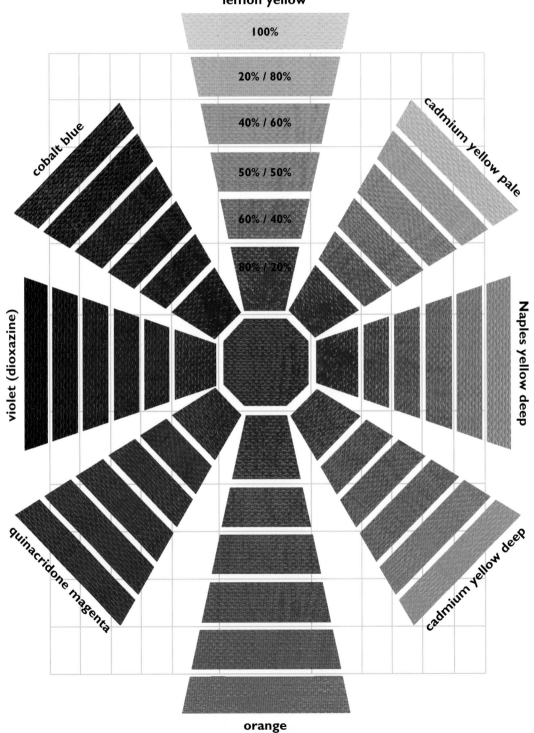

lemon yellow

100%

20% / 80%

40% / 60%

50% / 50%

60% / 40%

80% / 20%

cadmium yellow pale

cobalt blue

violet (dioxazine)

Naples yellow deep

quinacridone magenta

cadmium yellow deep

orange

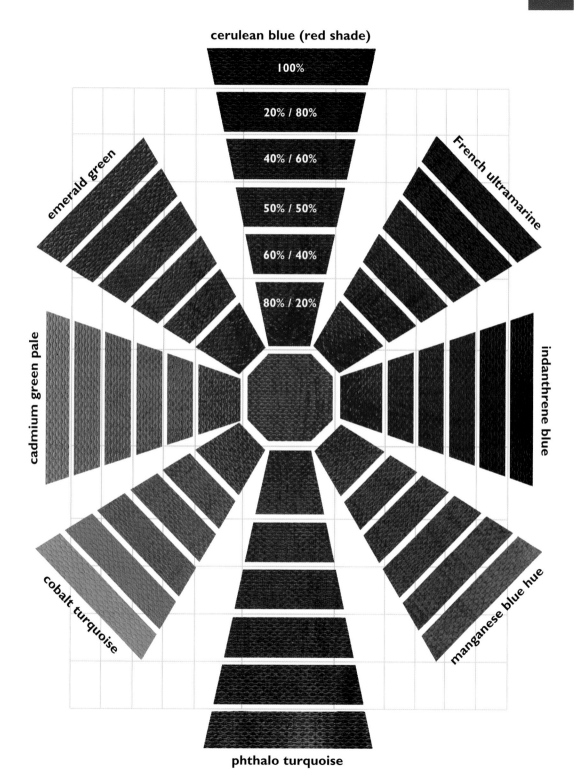

cerulean blue (red shade)

100%

20% / 80%

40% / 60%

50% / 50%

60% / 40%

80% / 20%

emerald green

French ultramarine

cadmium green pale

indanthrene blue

cobalt turquoise

manganese blue hue

phthalo turquoise

quinacridone magenta

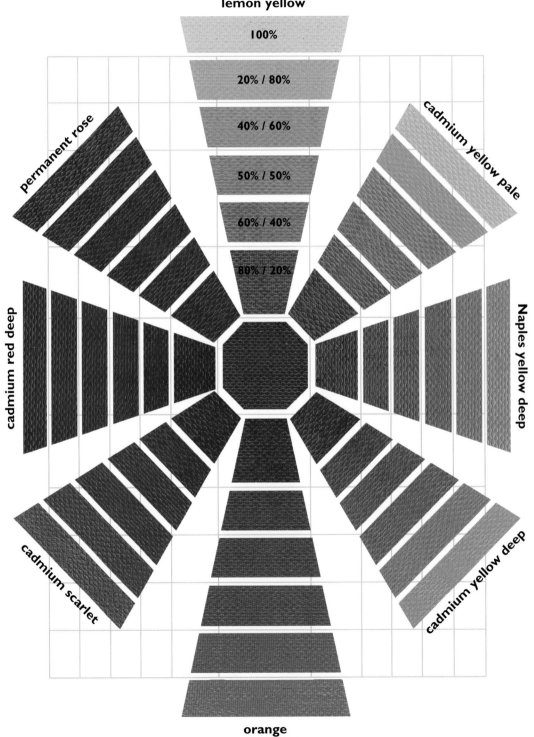

lemon yellow

100%

20% / 80%

40% / 60%

50% / 50%

60% / 40%

80% / 20%

permanent rose

cadmium yellow pale

cadmium red deep

Naples yellow deep

cadmium scarlet

cadmium yellow deep

orange

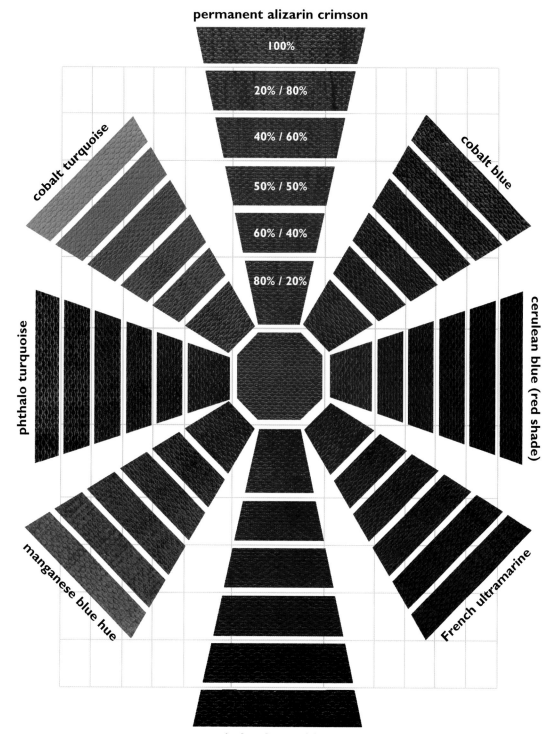

permanent alizarin crimson

100%

20% / 80%

40% / 60%

50% / 50%

60% / 40%

80% / 20%

cobalt turquoise

cobalt blue

phthalo turquoise

cerulean blue (red shade)

manganese blue hue

French ultramarine

indanthrene blue

violet (dioxazine)

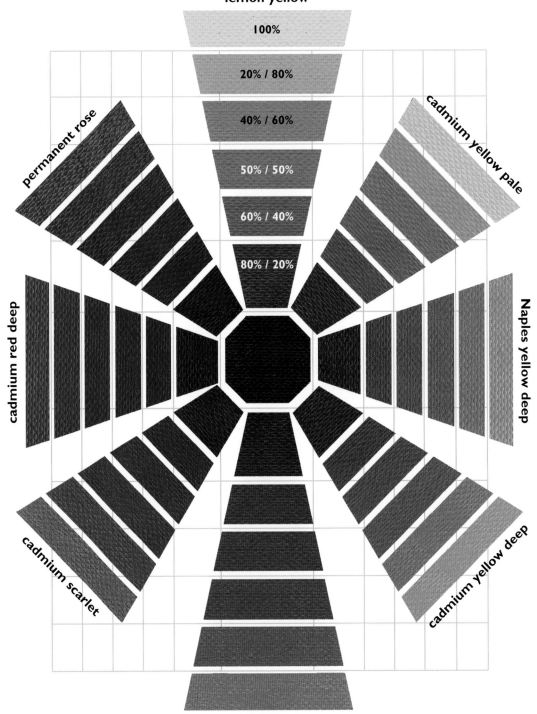

lemon yellow

100%

20% / 80%

40% / 60%

50% / 50%

60% / 40%

80% / 20%

permanent rose

cadmium yellow pale

cadmium red deep

Naples yellow deep

cadmium scarlet

cadmium yellow deep

orange

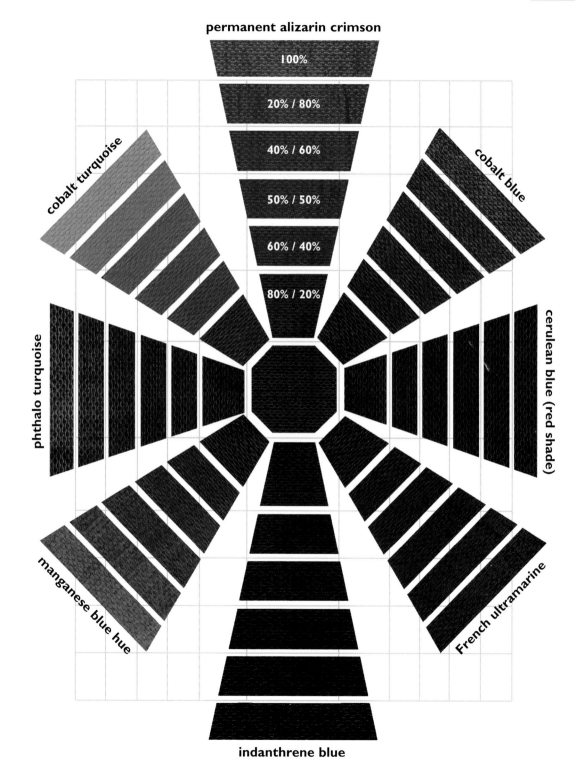

permanent alizarin crimson

100%

20% / 80%

40% / 60%

50% / 50%

60% / 40%

80% / 20%

cobalt turquoise

cobalt blue

phthalo turquoise

cerulean blue (red shade)

manganese blue hue

French ultramarine

indanthrene blue

cobalt blue

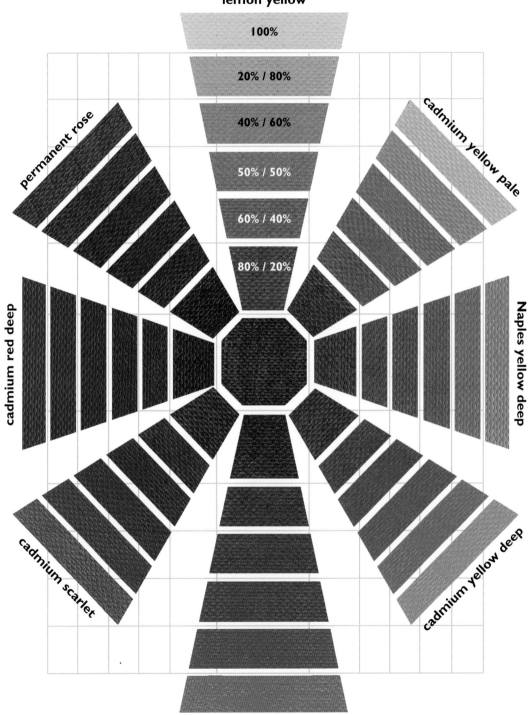

lemon yellow

100%

20% / 80%

40% / 60%

50% / 50%

60% / 40%

80% / 20%

permanent rose

cadmium yellow pale

cadmium red deep

Naples yellow deep

cadmium scarlet

cadmium yellow deep

orange

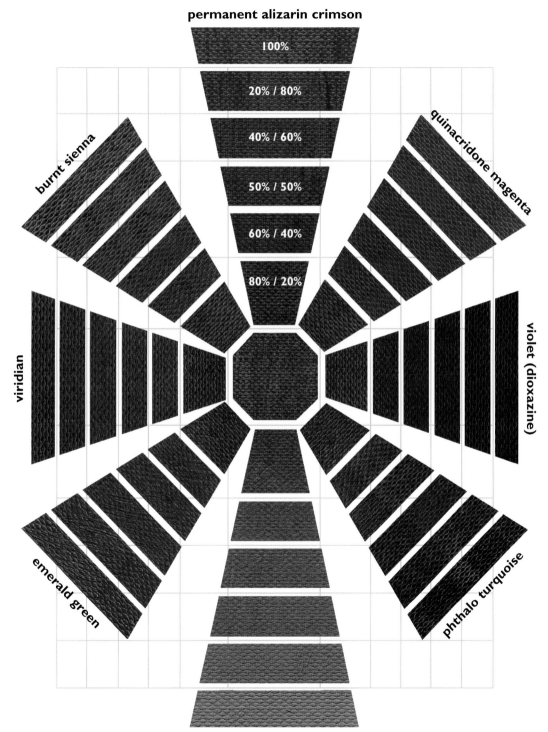

permanent alizarin crimson

100%

20% / 80%

40% / 60%

50% / 50%

60% / 40%

80% / 20%

burnt sienna

quinacridone magenta

viridian

violet (dioxazine)

emerald green

phthalo turquoise

cadmium green pale

cerulean blue (red shade)

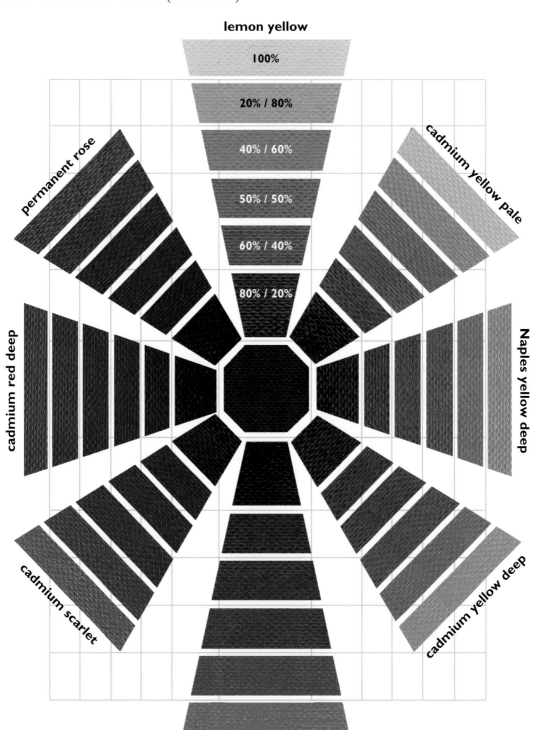

lemon yellow

100%

20% / 80%

40% / 60%

50% / 50%

60% / 40%

80% / 20%

permanent rose

cadmium yellow pale

cadmium red deep

Naples yellow deep

cadmium scarlet

cadmium yellow deep

orange

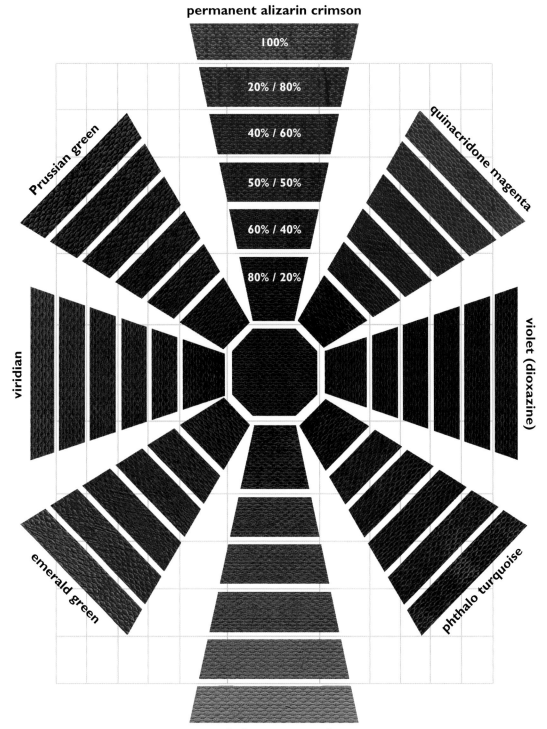

permanent alizarin crimson

100%

20% / 80%

40% / 60%

50% / 50%

60% / 40%

80% / 20%

Prussian green

quinacridone magenta

viridian

violet (dioxazine)

emerald green

phthalo turquoise

cadmium green pale

French ultramarine

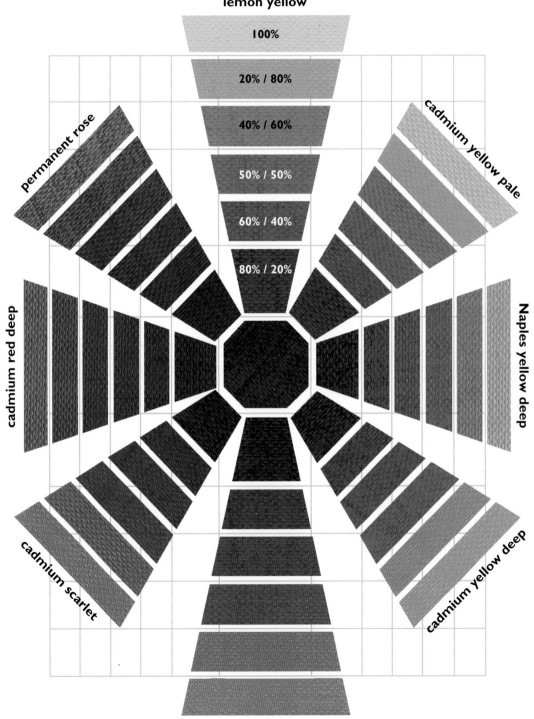

lemon yellow

100%

20% / 80%

40% / 60%

50% / 50%

60% / 40%

80% / 20%

permanent rose

cadmium yellow pale

cadmium red deep

Naples yellow deep

cadmium scarlet

cadmium yellow deep

orange

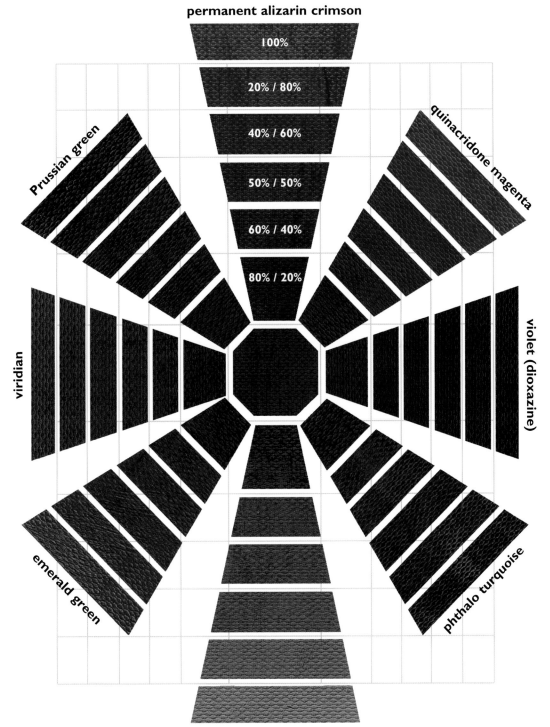

permanent alizarin crimson

100%

20% / 80%

40% / 60%

50% / 50%

60% / 40%

80% / 20%

Prussian green

quinacridone magenta

viridian

violet (dioxazine)

emerald green

phthalo turquoise

cadmium green pale

indanthrene blue

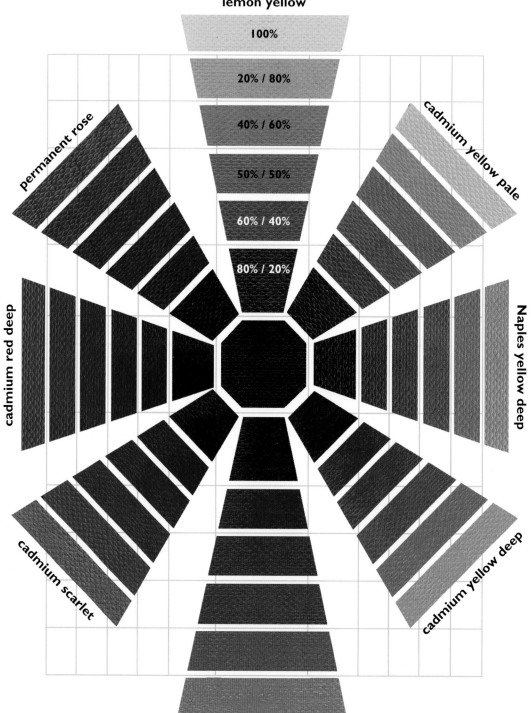

lemon yellow

100%

20% / 80%

40% / 60%

50% / 50%

60% / 40%

80% / 20%

permanent rose

cadmium yellow pale

cadmium red deep

Naples yellow deep

cadmium scarlet

cadmium yellow deep

orange

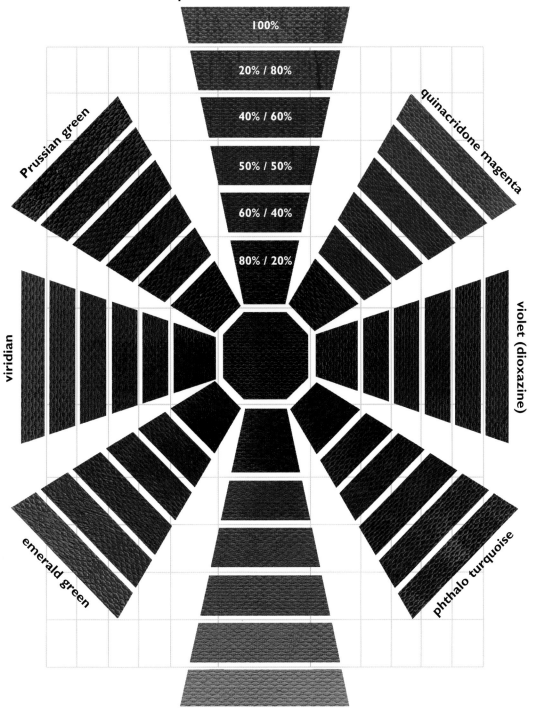

permanent alizarin crimson

100%

20% / 80%

40% / 60%

50% / 50%

60% / 40%

80% / 20%

quinacridone magenta

Prussian green

violet (dioxazine)

viridian

emerald green

phthalo turquoise

cadmium green pale

manganese blue hue

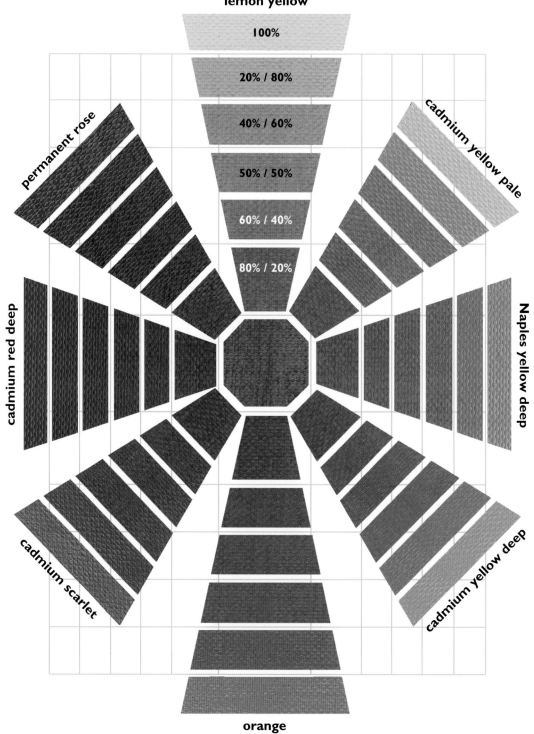

lemon yellow

100%

20% / 80%

40% / 60%

50% / 50%

60% / 40%

80% / 20%

permanent rose

cadmium yellow pale

cadmium red deep

Naples yellow deep

cadmium scarlet

cadmium yellow deep

orange

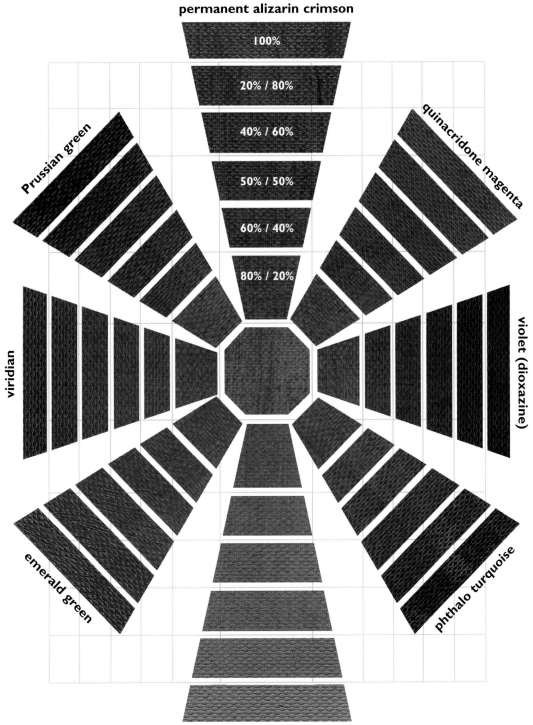

permanent alizarin crimson

100%

20% / 80%

40% / 60%

50% / 50%

60% / 40%

80% / 20%

quinacridone magenta

Prussian green

violet (dioxazine)

viridian

emerald green

phthalo turquoise

cadmium green pale

phthalo turquoise

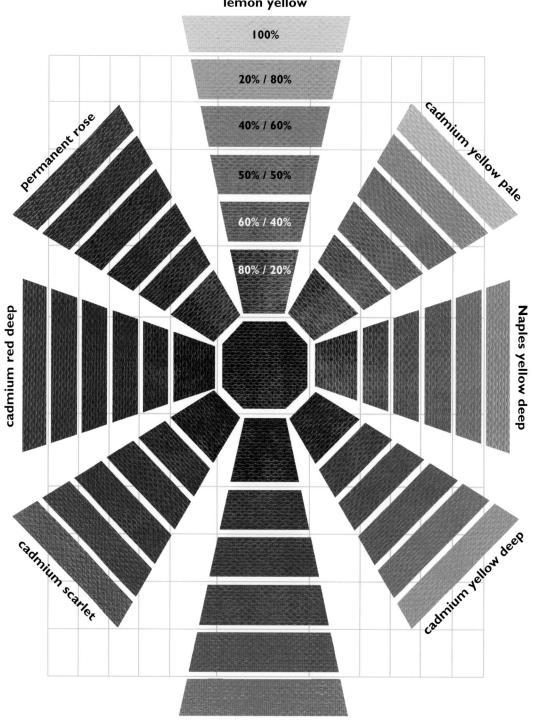

lemon yellow

100%

20% / 80%

40% / 60%

50% / 50%

60% / 40%

80% / 20%

permanent rose

cadmium yellow pale

cadmium red deep

Naples yellow deep

cadmium scarlet

cadmium yellow deep

orange

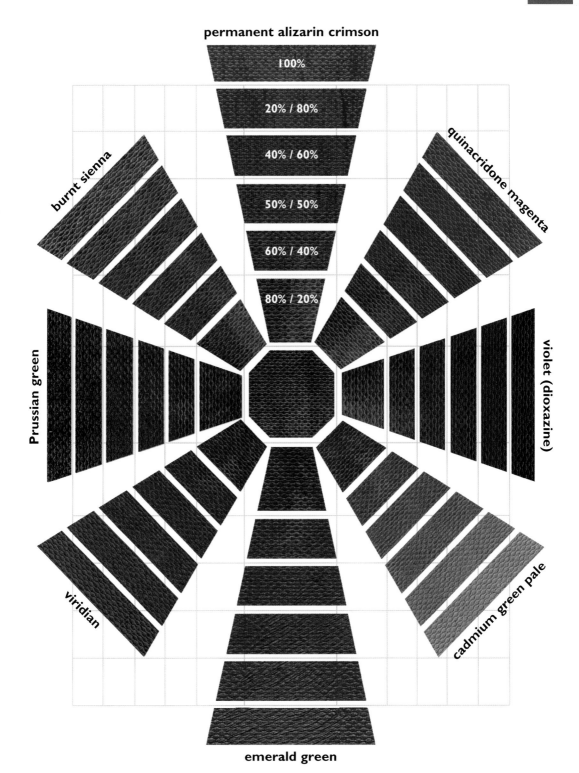

permanent alizarin crimson

100%

20% / 80%

40% / 60%

50% / 50%

60% / 40%

80% / 20%

burnt sienna

quinacridone magenta

Prussian green

violet (dioxazine)

viridian

cadmium green pale

emerald green

cobalt turquoise

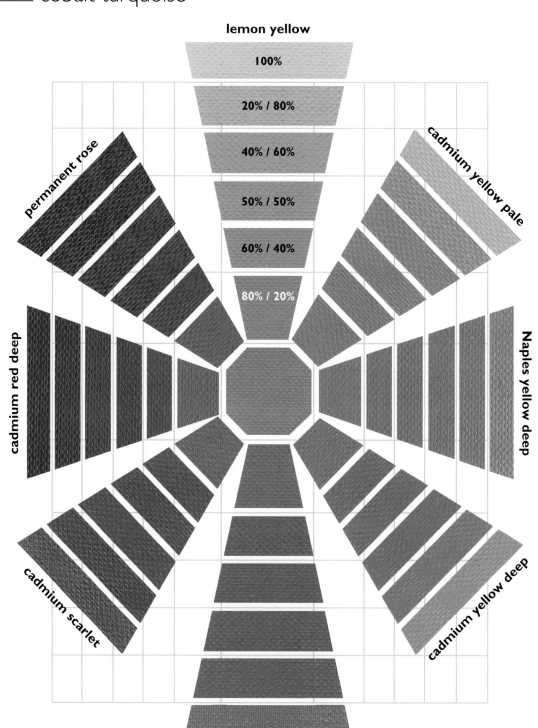

lemon yellow

100%

20% / 80%

40% / 60%

50% / 50%

60% / 40%

80% / 20%

permanent rose

cadmium yellow pale

cadmium red deep

Naples yellow deep

cadmium scarlet

cadmium yellow deep

orange

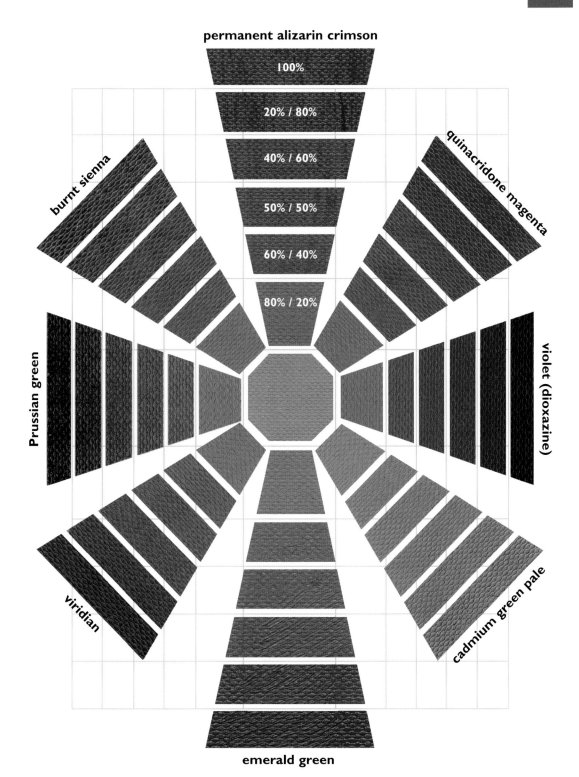

permanent alizarin crimson

100%

20% / 80%

40% / 60%

50% / 50%

60% / 40%

80% / 20%

burnt sienna

quinacridone magenta

Prussian green

violet (dioxazine)

viridian

cadmium green pale

emerald green

cadmium green pale

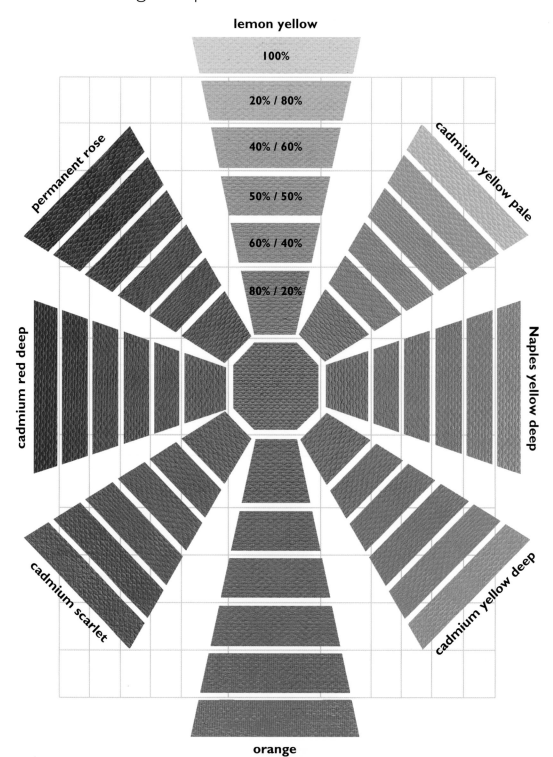

lemon yellow

100%

20% / 80%

40% / 60%

50% / 50%

60% / 40%

80% / 20%

permanent rose

cadmium yellow pale

cadmium red deep

Naples yellow deep

cadmium scarlet

cadmium yellow deep

orange

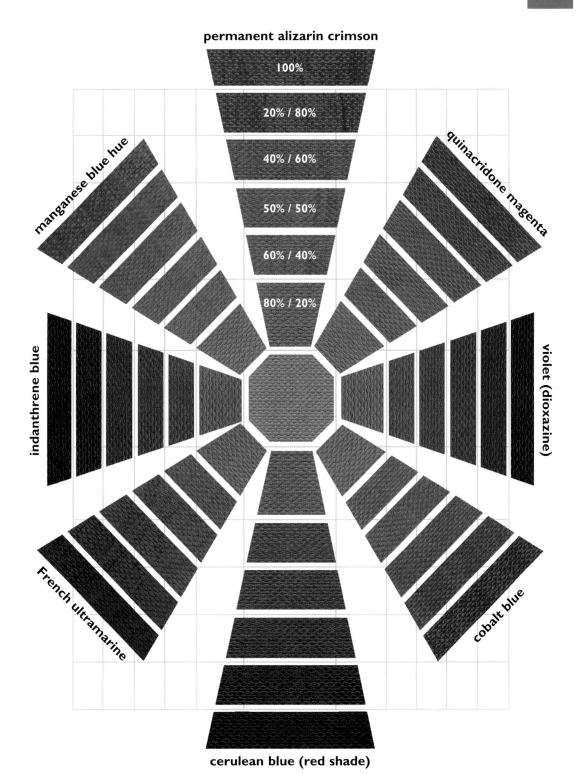

permanent alizarin crimson

100%

20% / 80%

40% / 60%

50% / 50%

60% / 40%

80% / 20%

manganese blue hue

quinacridone magenta

indanthrene blue

violet (dioxazine)

French ultramarine

cobalt blue

cerulean blue (red shade)

emerald green

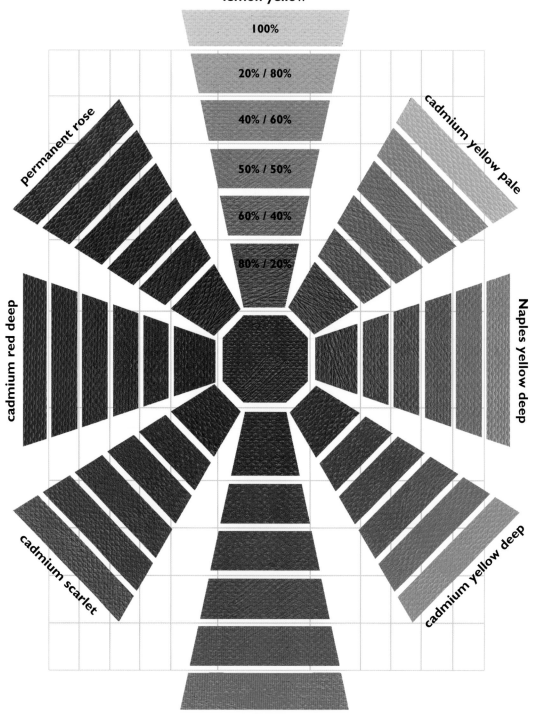

lemon yellow

100%

20% / 80%

40% / 60%

50% / 50%

60% / 40%

80% / 20%

permanent rose

cadmium yellow pale

cadmium red deep

Naples yellow deep

cadmium scarlet

cadmium yellow deep

orange

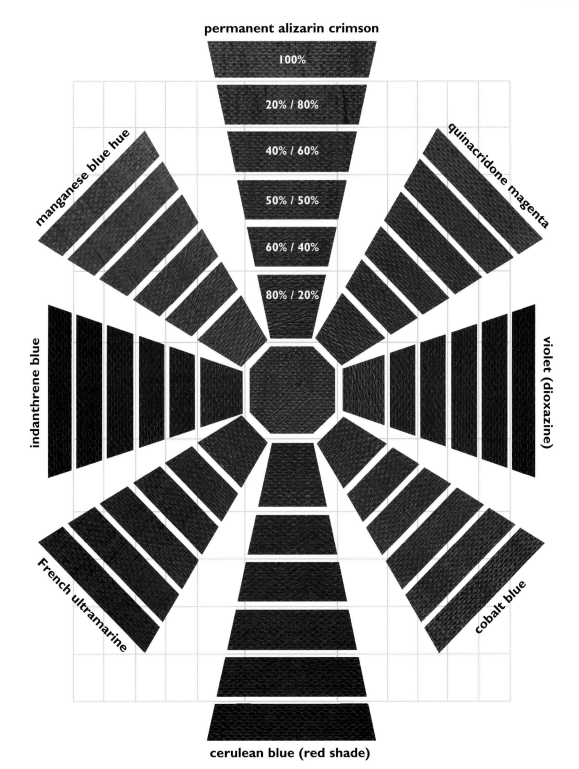

permanent alizarin crimson

100%

20% / 80%

40% / 60%

50% / 50%

60% / 40%

80% / 20%

manganese blue hue

quinacridone magenta

indanthrene blue

violet (dioxazine)

French ultramarine

cobalt blue

cerulean blue (red shade)

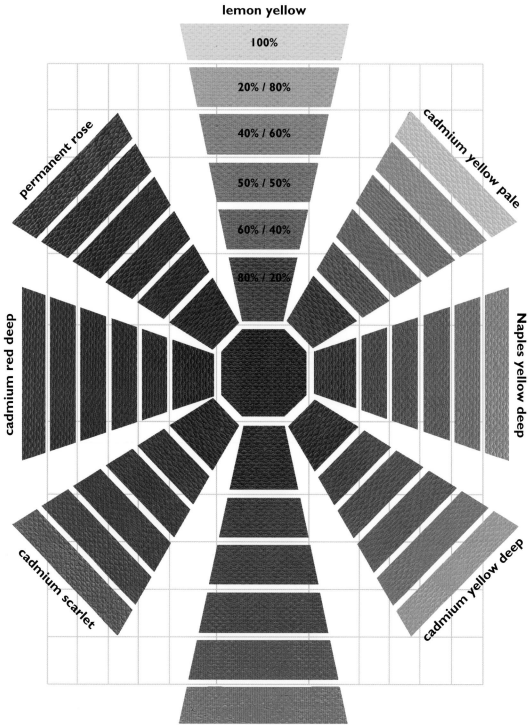

lemon yellow

100%

20% / 80%

40% / 60%

50% / 50%

60% / 40%

80% / 20%

permanent rose

cadmium yellow pale

cadmium red deep

Naples yellow deep

cadmium scarlet

cadmium yellow deep

orange

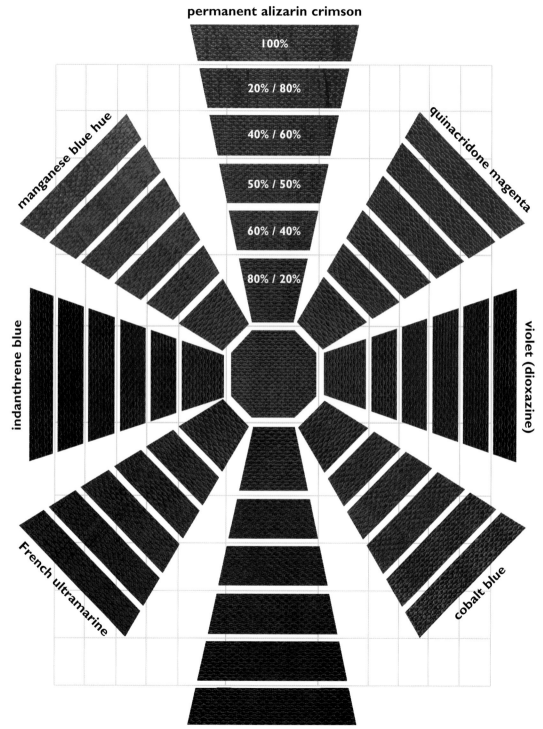

permanent alizarin crimson

100%

20% / 80%

40% / 60%

50% / 50%

60% / 40%

80% / 20%

manganese blue hue

quinacridone magenta

indanthrene blue

violet (dioxazine)

French ultramarine

cobalt blue

cerulean blue (red shade)

Prussian green

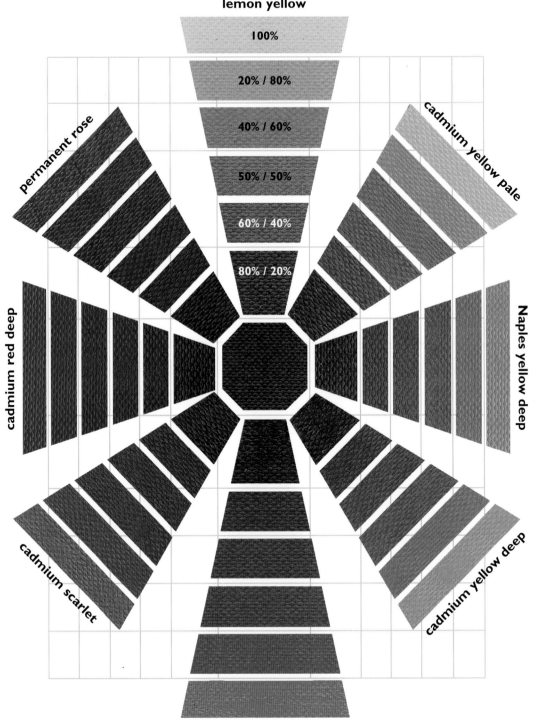

lemon yellow

100%

20% / 80%

40% / 60%

50% / 50%

60% / 40%

80% / 20%

cadmium yellow pale

permanent rose

Naples yellow deep

cadmium red deep

cadmium scarlet

cadmium yellow deep

orange

permanent alizarin crimson

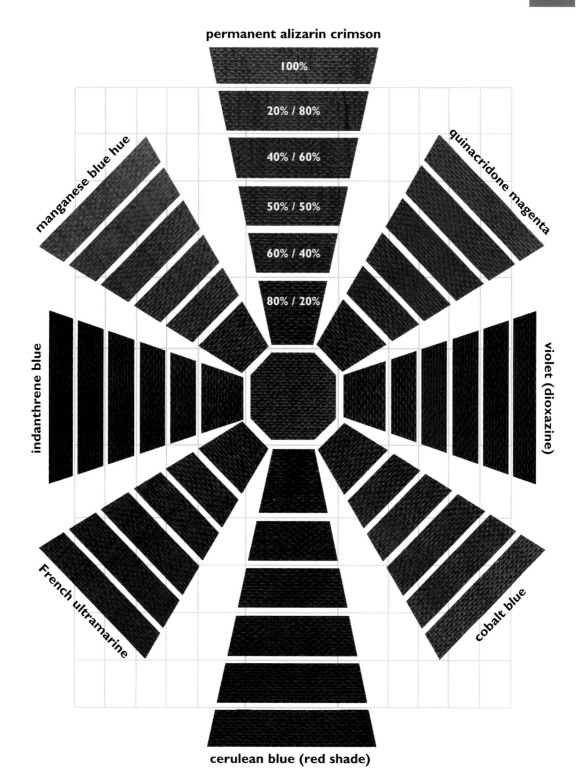

100%

20% / 80%

40% / 60%

50% / 50%

60% / 40%

80% / 20%

manganese blue hue

quinacridone magenta

indanthrene blue

violet (dioxazine)

French ultramarine

cobalt blue

cerulean blue (red shade)

burnt sienna

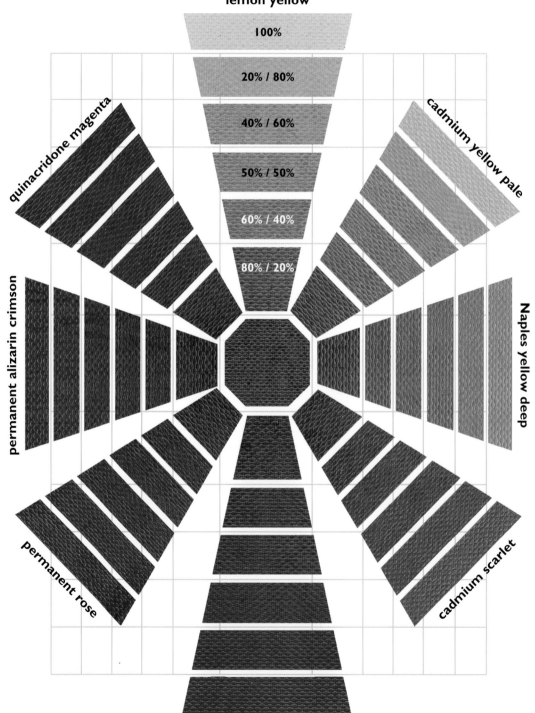

lemon yellow

100%

20% / 80%

40% / 60%

50% / 50%

60% / 40%

80% / 20%

quinacridone magenta

cadmium yellow pale

permanent alizarin crimson

Naples yellow deep

permanent rose

cadmium scarlet

cadmium red deep

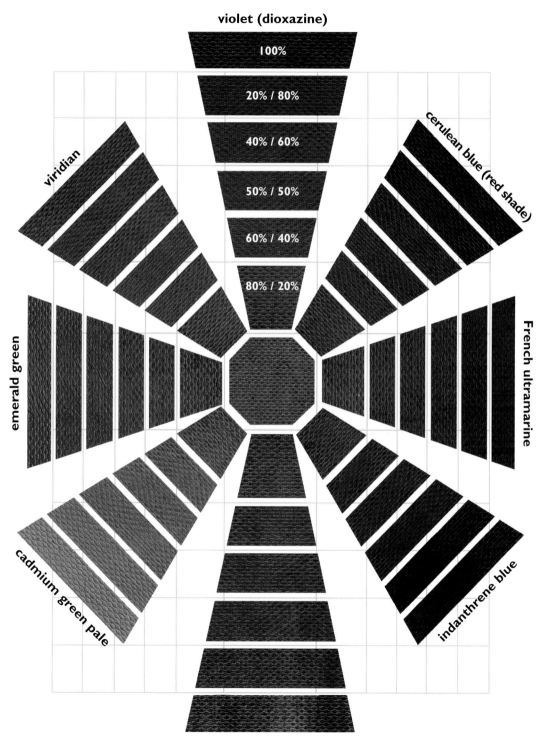

violet (dioxazine)

100%

20% / 80%

40% / 60%

50% / 50%

60% / 40%

80% / 20%

cerulean blue (red shade)

viridian

emerald green

French ultramarine

cadmium green pale

indanthrene blue

phthalo turquoise

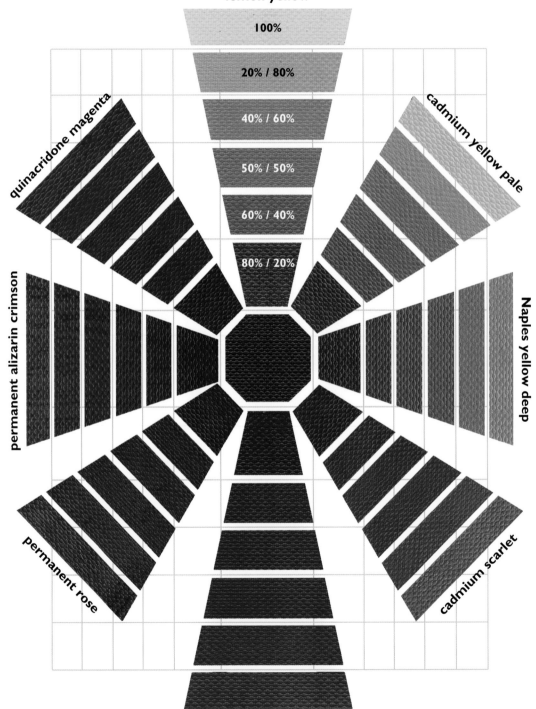

lemon yellow

100%

20% / 80%

40% / 60%

50% / 50%

60% / 40%

80% / 20%

quinacridone magenta

cadmium yellow pale

permanent alizarin crimson

Naples yellow deep

permanent rose

cadmium scarlet

cadmium red deep

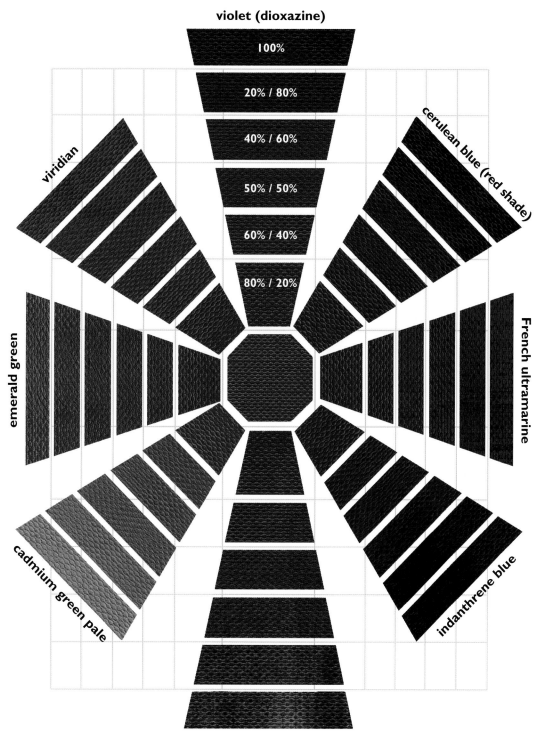

violet (dioxazine)

100%

20% / 80%

40% / 60%

50% / 50%

60% / 40%

80% / 20%

viridian

cerulean blue (red shade)

emerald green

French ultramarine

cadmium green pale

indanthrene blue

phthalo turquoise

raw umber

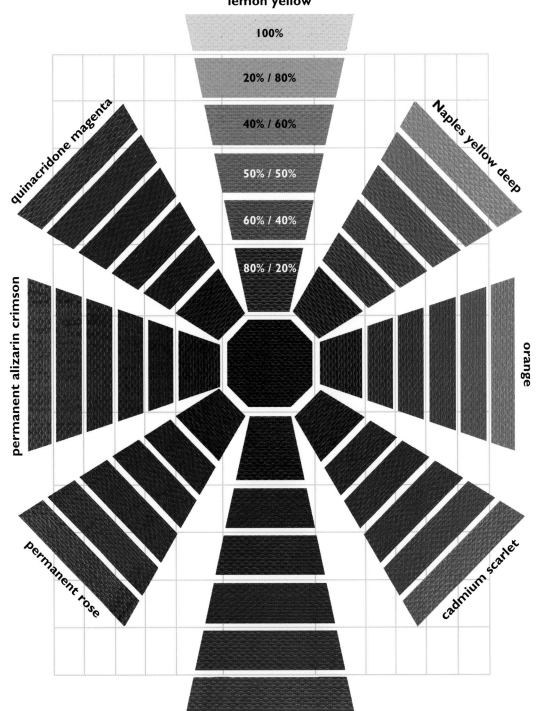

lemon yellow

100%

20% / 80%

40% / 60%

50% / 50%

60% / 40%

80% / 20%

quinacridone magenta

Naples yellow deep

permanent alizarin crimson

orange

permanent rose

cadmium scarlet

cadmium red deep

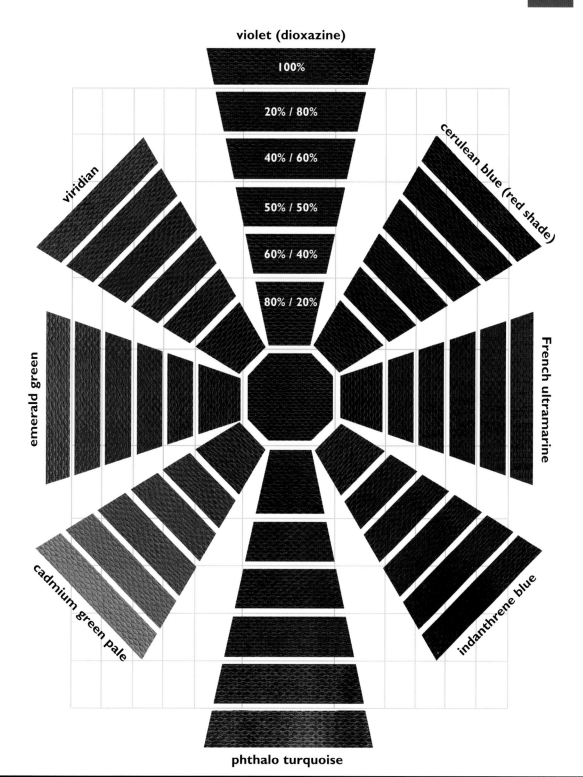

violet (dioxazine)

100%

20% / 80%

40% / 60%

50% / 50%

60% / 40%

80% / 20%

viridian

cerulean blue (red shade)

emerald green

French ultramarine

cadmium green pale

indanthrene blue

phthalo turquoise

index